GOL

BRITAIN IN PICTURES

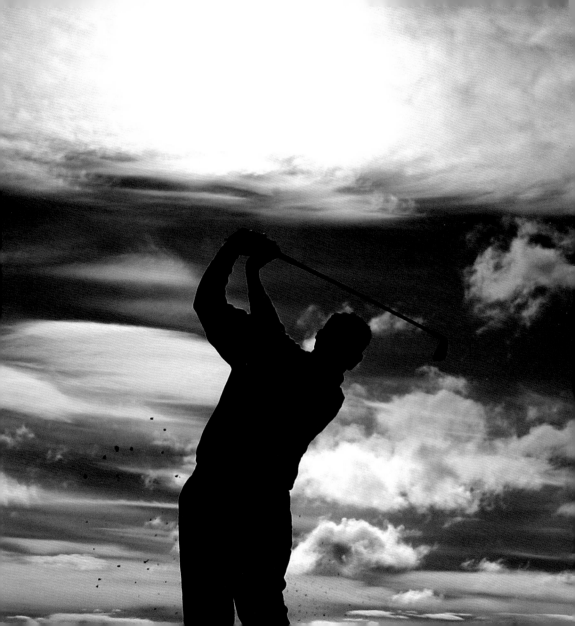

GOLF

BRITAIN IN PICTURES

AMMONITE
PRESS

PRESS
ASSOCIATION
Images

First published 2012 by
Ammonite Press
an imprint of AE Publications Ltd,
166 High Street, Lewes, East Sussex, BN7 1XU

This title has been created using material first published in
100 Years of Golf (2008)

ISBN 978-1-90770-843-5

British Cataloguing in Publication Data. A catalogue
record of this book is available from the British Library.

Editor: Rob Yarham
Managing Editor: Richard Wiles
Picture research: Press Association Images
Designer: Jo Patterson

Colour reproduction by GMC Reprographics
Printed and bound in China by C&C Offset Printing Co. Ltd

Contents

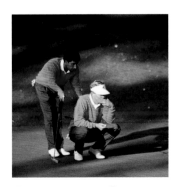
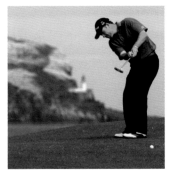

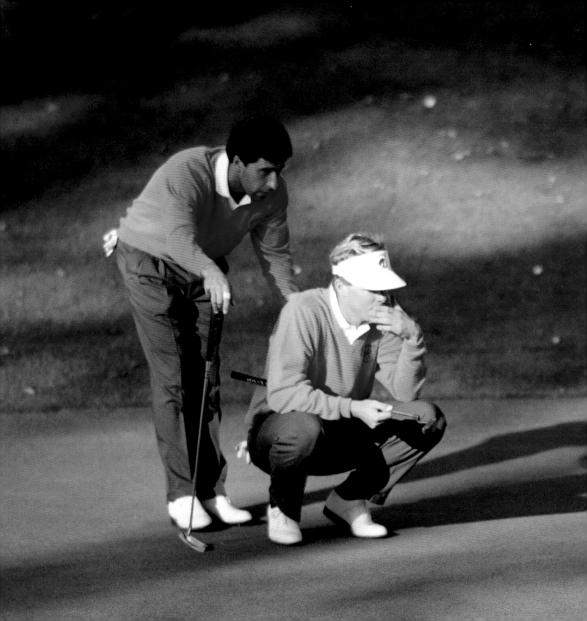

Chapter One
PEOPLE

GOLFING HEROES

As the 20th century dawned on the fairways and greens of the British Isles, three players dominated the world of golf.

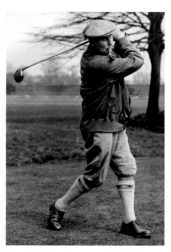

Harry Vardon, known as 'Mr Golf', won a record six Open Championships. 1920

John Henry (J.H.) Taylor, Harry Vardon and James Braid were called the 'Great Triumvirate'. While on an exhibition tour in 1900, Vardon landed the US Open using the 'Vardon Flyer' golf ball. He was a great ambassador for the game and it was that tour which is said to have spurred interest in golf in America. Vardon was the first player to win both Opens.

Taylor, meanwhile, played until well into his fifties and became one of the driving forces behind the formation of the Professional Golfers Association (PGA) in Britain. After he retired, course design became the great passion

for Braid and it is estimated that he was involved in the building, or redesign, of more than 200.

Worthy of ranking alongside them, however, are John Ball Jr, Abe Mitchell and Edward 'Ted' Ray, whose achievements seemed to be overshadowed by the great threesome.

Ball won the Amateur title, which was considered one of the top tournaments, eight times and also captured the British Open – the first amateur to do so – in 1890. He continued to play competitive golf until he retired, after taking part in the 1921 Amateur Open. Mitchell was acknowledged as the greatest

striker of a ball in his era. Ray was captain of the Great Britain & Ireland team that played against the United States in 1926, spawning the Ryder Cup.

The sport grabbed the interest of the big manufacturing companies and Goodrich Rubber patented a machine for winding the rubber threads around the core of a Haskell ball. Mass production soon followed. A

few years later, Scottish golfer Sandy Herd was the first player to use the Haskell to win both the Hoylake (England) Open and the British Open. His appearances in the latter tournament spanned 50 years, with his last being at the venerable age of 71 in 1939.

It was in the first decade of the new century that women's golf began to take off, and in 1908 Mrs Gordon Robertson became the first female professional.

As the First World War loomed, Harry Vardon won his sixth Open, while Walter Hagen was the new rising star from across the Atlantic and he marked the beginning of the professional golfer.

THE 1920s
With the arrival of the 1920s, Jock Hutchison, born in Scotland, became the first US-based golfer to land Britain's major title. To achieve the feat, he used deep-grooved irons, which were to be banned four years later.

The 1920s also saw the birth of the Walker Cup, for amateurs, and the Ryder Cup, for the professionals, as biennial team competitions between Britain and Ireland and America. The names that reverberated around the amateur ranks during the 1920s were those of Joyce and Roger Wethered, with the former regarded as the greatest British woman player of her time.

THE 1930s AND 1940s
It took until the late 1930s before the amateurs could defeat the Americans in the Walker Cup, but their professional counterparts achieved victory in the second event in 1929 at a cold and snowy Moortown Golf Club in Leeds when captain George Duncan, who had won the first post-war Open in 1920, lifted the Ryder Cup. One of Duncan's teammates that year was a young Henry Cotton, who went on to dominate British golf during the 1930s and 1940s. He won his first contest at the age of 16 in 1923 and promptly turned professional a year later along with his brother Leslie.

The last pre-war Open was held at St Andrews. Victory went to Richard 'Dick' Burton, who is best remembered for holding the Open title for the longest

American star Sam Snead practises for the Ryder Cup at Wentworth.
30th September, 1953

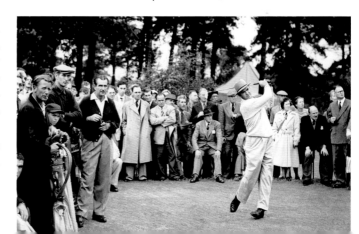

time because of the intervening war years. As the world returned to normal, Cotton won the last of his three Open titles in 1948. He served as captain in the Ryder Cup the year before and would do so again six years later.

During this period, the US had its own great triumvirate in Ben Hogan, Byron Nelson and Sam Snead. Golf was televised in the States for the first time when the 1947 US Open was broadcast.

When the Second World War ended, Max Faulkner's career started: he was one of the game's most flamboyant characters, typically attired in colourful clothes such as salmon-pink plus fours.

THE 1950s AND 1960s

During this era, the career of Neil Coles began. He remains the only man to win a professional golf tournament in six different decades. His first victory came in 1956 and his last in 2002 when he won the Lawrence Batley Seniors tournament aged 67.

In the 1960s, improvements in transatlantic travel saw more American golfers crossing the ocean. The decade also saw the emergence of Scunthorpe-born Tony Jacklin as a major force in golf, as he would continue to be well into the 1970s.

THE 1970s

In 1970, Peter Oosterhuis was the next brightest star on the horizon, following a distinguished amateur career representing Britain in the Walker Cup and Eisenhower Trophy. The Londoner went on to finish runner-up in the Open on two occasions and won the European Order of Merit title four years in a row (1971–1974). He played in the Ryder Cup six times from 1971 to 1981, and among the famous scalps he took were those of Arnold Palmer and Johnny Miller.

Like Oosterhuis, Essex-born Michael Bonallack had a brilliant career in the unpaid ranks, winning the Amateur Championship five times. When he finally put his clubs down from competitive playing, he became one of the sport's leading administrators and was knighted in 1998.

England's Trevor Homer and Peter McEvoy each won the Amateur title twice in the 1970s. The decade also saw the first metal woods.

Tony Jacklin tees off at the British Open at Royal Lytham & St Annes.
12th July, 1969

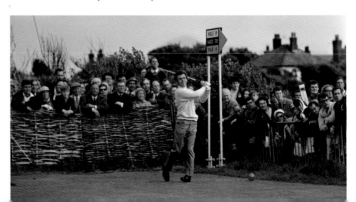

THE 1980s ONWARDS

In the 1980s there was another resurgence for British golf through the exploits of Nick Faldo, Sandy Lyle and Ian Woosnam. Hertfordshire-born Faldo took up the game when he borrowed some clubs from a neighbour after watching American Jack Nicklaus play the 1971 US Masters on TV.

Faldo won the English Amateur title while working as a carpet fitter. After turning pro, he became, at the time, the youngest golfer to play in the Ryder Cup and was considered the best golfer in the world.

Although born in Shrewsbury, Lyle went to live in Scotland when his father became resident professional at the Hawkstone Park golf club. He topped the Merit table three times, including twice in the 1980s.

Woosnam's career took off in 1982 after he won the Swiss Open and he reached the top of the tree in 1991 when he was officially ranked world No 1.

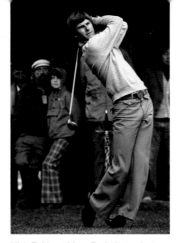

Nick Faldo at Moor Park. Later that year he played in his first Ryder Cup. 25th June, 1977

One of the first British golfers to go to a US college was Colin Montgomerie, who was named the European Tour's Rookie of the Year in 1988. A year later he won his first title by eight shots and made his Ryder Cup debut in 1991. Between 1993 and 1999, he set the record for the most Order of Merit titles won and eventually reached second in the world rankings.

The 1990s also witnessed the arrival of Darren Clarke and Lee Westwood, who would become mainstays in the Ryder Cup throughout the decade and into the next. Justin Rose came to prominence in the 1998 Open, finishing fourth as a 17-year-old amateur. Four years later he won his first professional tournament.

Just as the century had started with a British victory in the Open, so it closed the same way with Scotsman Paul Lawrie winning the 1999 Open at Carnoustie in Angus, Ayrshire. Another Scottish course, Nairn on the shores of the Moray Firth was host to a British victory, with Peter McEvoy leading the amateurs to victory in the Walker Cup.

Golf is an international sport, and many of the great moments in British golf have come from players from around the world. This book also features many of the key international characters who have contributed to the game in Britain, including Walter Hagen, Ben Hogan, Arnold Palmer, Jack Nicklaus, Gary Player, Seve Ballesteros, Greg Norman and Tiger Woods.

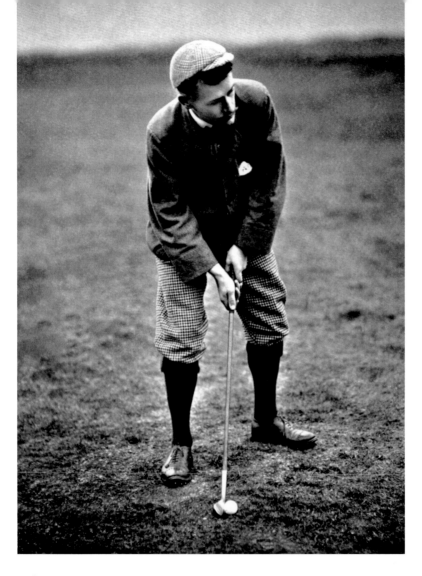

Harold Hilton became the second amateur to win an Open Championship – a feat only ever accomplished by three men – when he won at Muirfield in 1892. He won another in 1897 at the Royal Liverpool Golf Club.

1895

Johnny Laidlay
demonstrates the
overlapping grip that he
invented, and which was
made popular by Harry
Vardon and adopted by
many other golfers since.
1895

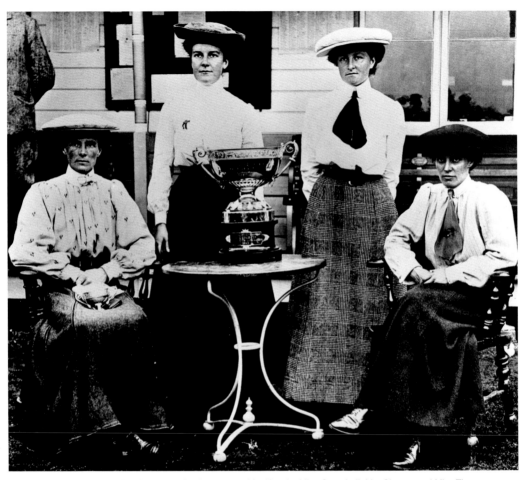

The Ladies semi-finalists at Burnham pose for the camera: Mrs Kennin, Miss Campbell, Mrs Simster and Miss Thompson.
1906

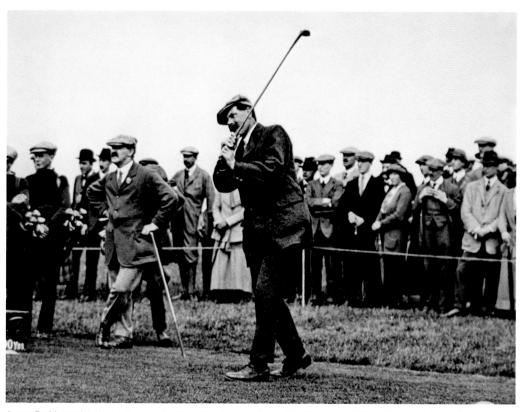

James Braid, watched by another great golfer of the day, J.H. Taylor (L), drives a 'guttie' (or Gutta-percha) from the tee in a match to determine the relative values of two types of ball: the guttie (a hard, latex ball with a smooth surface) and the predecessor of today's ball, which used a rubber core and a dimpled surface.
2nd April, 1914

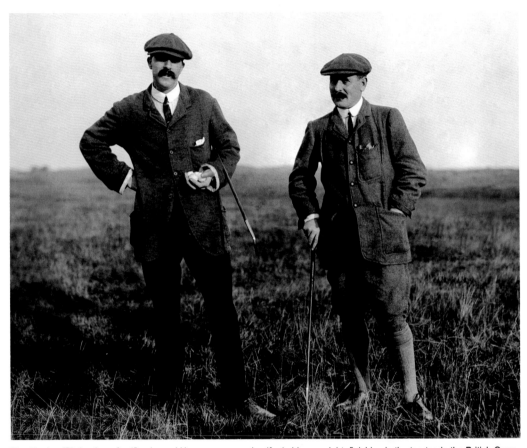

Tom Vardon (R), brother of golfing legend Harry, was a good golfer in his own right, finishing in the top ten in the British Open eight times. Here he is with his caddy Ray during the 1909 Open held at the Royal Cinque Ports Golf Club in Deal, Kent.
23rd July, 1909

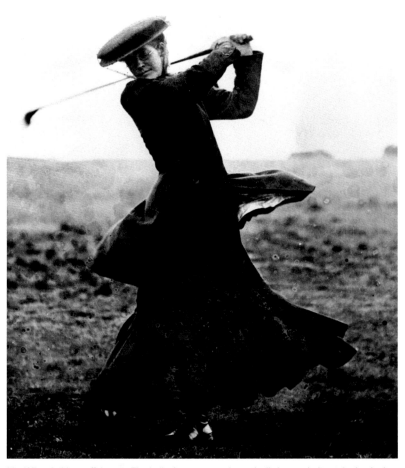

Mrs Wilcock drives off the tee. The ladies' game grew dramatically in popularity at the beginning of the 20th century.
1912

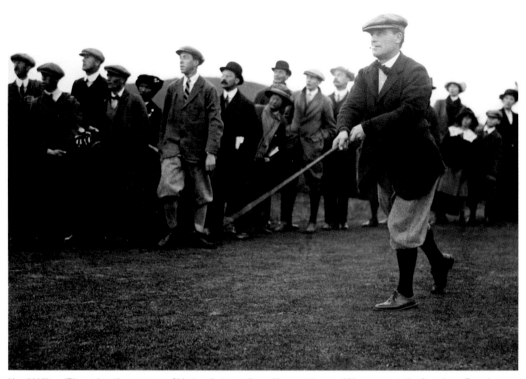

Harold Hilton (R) watches the progress of his tee shot, together with spectators and his opponent, the American, Francis Ouimet (sixth L), at the International Competition at Sunningdale. Ouimet, winner of the US Open in 1913, was one of the very first golfers to use the interlocking grip, used by many leading golfers including Jack Nicklaus and Tiger Woods.
10th October, 1913

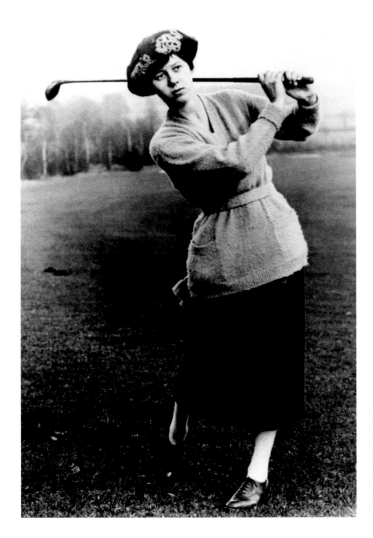

Joyce Wethered plays a shot at
Portrush. Wethered was widely
regarded as the greatest British female
golfer of her day and won
the British Ladies Amateur Golf
Championship four times and was
the British Ladies Champion for five
consecutive years.
1920

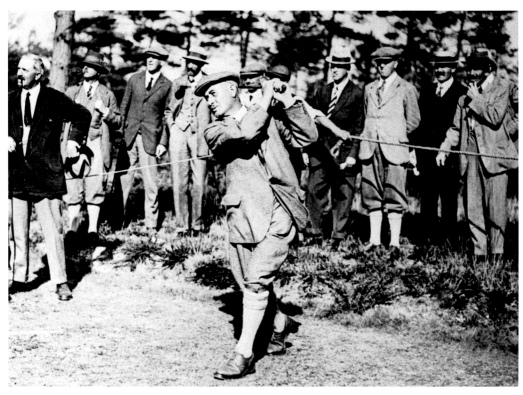

Jersey-born Harry Vardon was the first golfer to wear knickerbockers and, perhaps more significantly, developed a demanding practice regime in his early 20s to systematically improve his game. His results demonstrated the effectiveness of his technique: he won a remarkable 62 tournaments, 14 of which he won consecutively, still a record today.

17th October, 1921

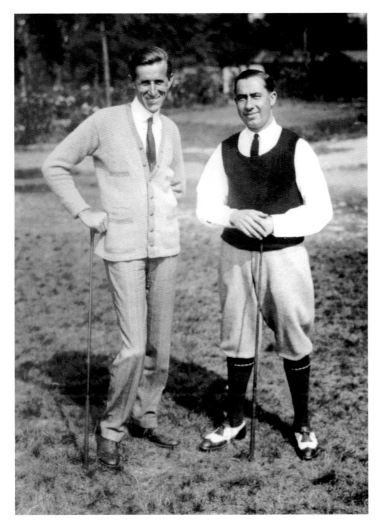

Two leading golfers of their day: Jim Barnes (L) and Walter Hagen. Barnes (also known as 'Long Jim') was born in Britain, but left for the US where he turned professional in 1906. He won the very first two US PGA Championships in 1916 and 1919, a US Open and a British Open. Hagen won 11 professional majors, including two US Opens, four British Opens and five US PGA Championships.

1st June, 1923

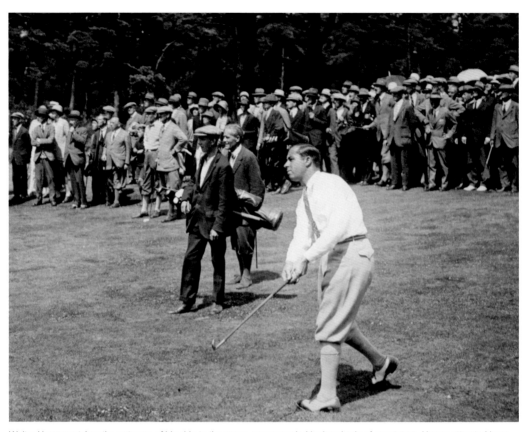

Walter Hagen watches the outcome of his chip to the green, accompanied by hundreds of spectators. Hagen attracted huge crowds wherever he went, enabling him to charge large appearance fees and capitalise on his image with product endorsements. He is thought to be the first professional sportsman to earn a million dollars in a career.
12th July, 1924

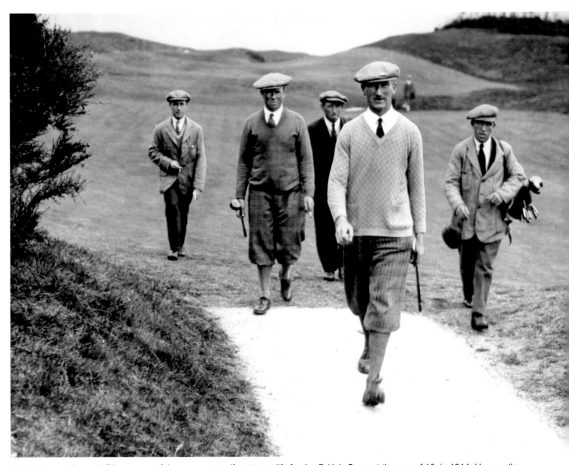

Arthur Havers (second R) was one of the youngest golfers to qualify for the British Open at the age of 16, in 1914. He won the event when it was held at Troon in 1923, and went on to play in the Ryder Cup three times.
1st June, 1928

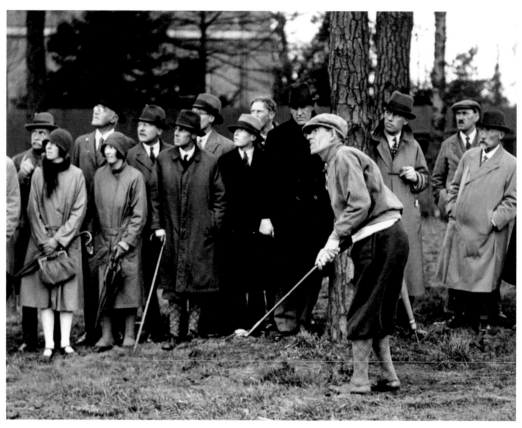

George Duncan plays a shot from an awkward lie at the sixth hole at Roehampton during a professional tournament. The only spectator with his eyes on Duncan and not the ball is former British Heavyweight Boxing Champion Bombardier Billy Wells.
10th April, 1929

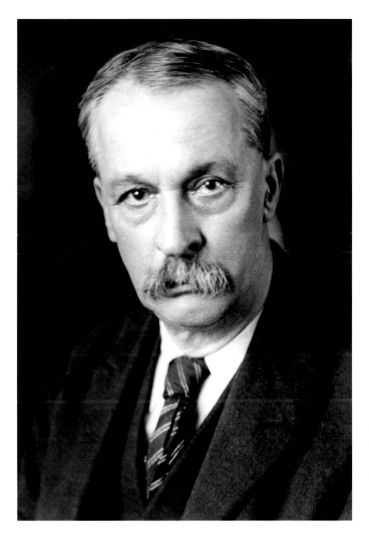

Samuel Ryder, English businessman, entrepreneur and keen golf enthusiast and promoter. He funded an international competition in 1926 and donated a gold trophy, the Ryder Cup, for the first biennial competition between the leading British and US professional golfers in 1927.
1st March, 1930

England's Abe Mitchell (L) and George Duncan (R) line up alongside their opponents, USA's Walter Hagen (second L) and Jim Barnes (second R), before the start of their England V USA four-ball match at Addington in England. The American pair would go on to win the event.

12th June, 1920

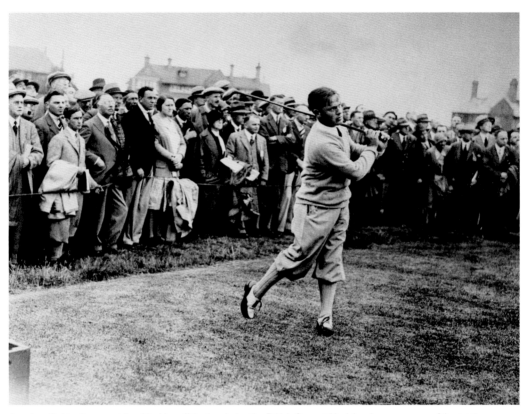

American Bobby Jones watches his drive off the tee during the British Open at Hoylake. Jones was one of the most successful amateur golfers of all time, winning six amateur championships and seven Opens (four US Opens and three British Opens). He earned his living as a lawyer, but on retiring was instrumental in setting up the Augusta National Course and the famous Masters tournament.

20th June, 1930

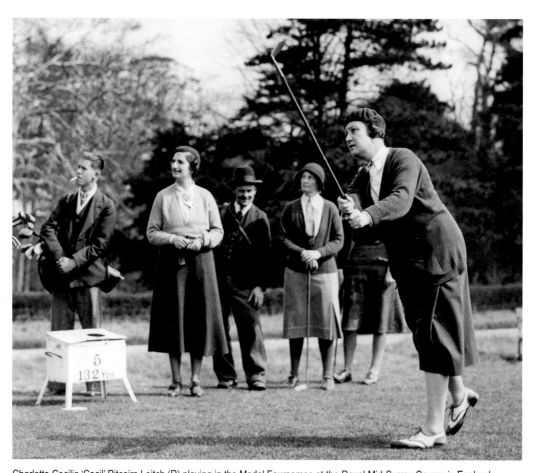

Charlotte Cecilia 'Cecil' Pitcairn Leitch (R) playing in the Medal Foursomes at the Royal Mid-Surrey Course in England. Cumberland-born Cecil won four British Ladies Amateur titles and was one of three sisters who excelled in golf.
7th April, 1933

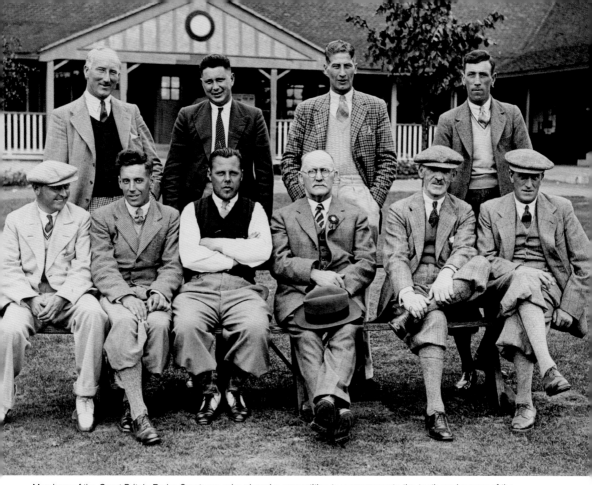

Members of the Great Britain Ryder Cup team, who played a competition to commemorate the tenth anniversary of the opening of Richmond Public Course: (back row, L–R) Arthur Havers, Syd Easterbrook, Allan Dailey, Alf Padgham; (front row, L–R) Alf Perry, Arthur Lacey, Percy Alliss, non-playing captain J.H. Taylor, Abe Mitchell and Charles Whitcombe.
10th June, 1933

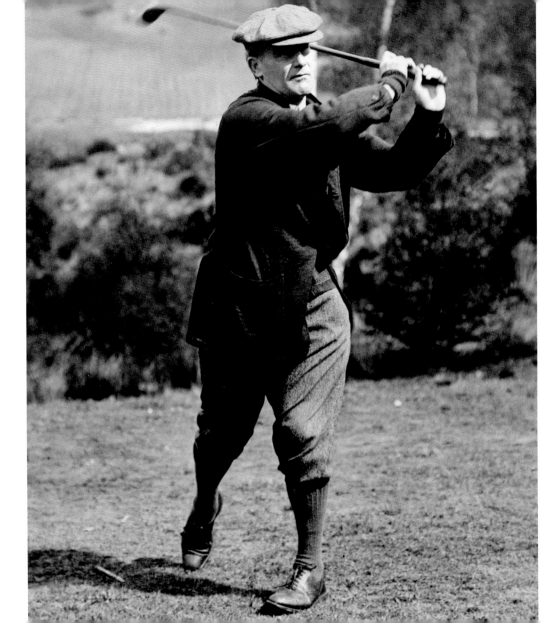

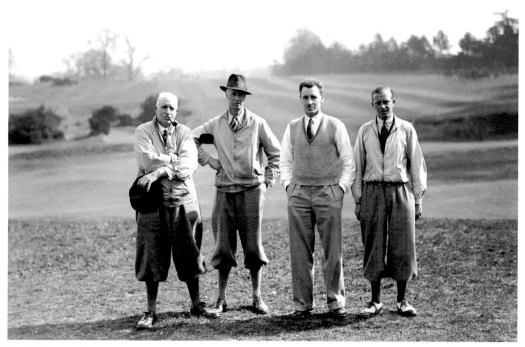

The Hertfordshire County Professional Golfers' Alliance line up for the cameraman: (L–R) Ted Ray, C.K. Cotton, M.C. Park and S.S. Field. Ted Ray was the British team captain for the very first Ryder Cup in 1927.
18th March, 1935

Facing page: Harold Hilton playing in the Gold Vase
Competition at St George's Hill Course, Weybridge in England.
Hilton retired with a remarkable 99-29 record (77.3 per cent) at
the Amateur Championship.
25th October, 1933

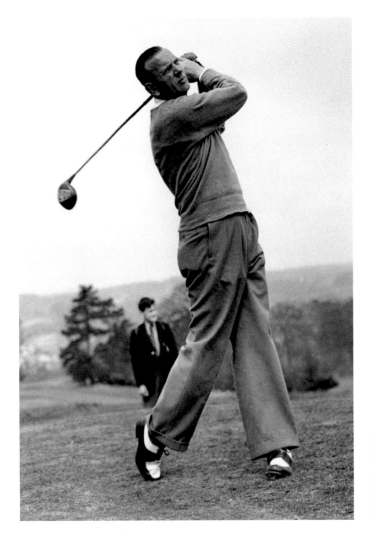

Leading English professional golfer Dick Burton at the Silver King Tournament at Moor Park in Hertfordshire, England. Burton won the British Open in 1939, and played in the Ryder Cup three times.
13th April, 1948

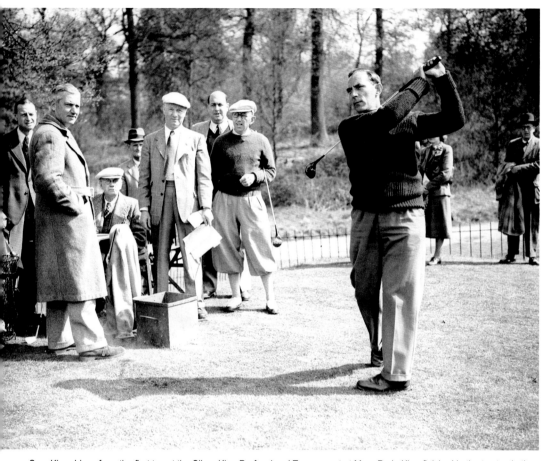

Sam King drives from the first tee at the Silver King Professional Tournament at Moor Park. King finished in the top ten in the British Open Championship nine times and played in three Ryder Cups.
21st April, 1949

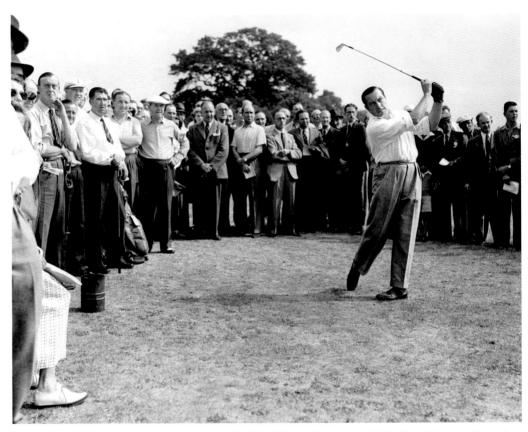

Watched by a large gallery, the English professional golfer Henry Cotton, winner of three British Open Championships and twice Ryder Cup captain, tees off during a match between the amateur British Walker Cup team and a team of professionals.
23rd July, 1949

Mildred 'Babe' Zaharias (L) strolls down the fairway with her playing partner. Zaharias was an American athlete who turned to golf in 1935 after achieving great success in athletics (winning two gold medals and one silver in the 1932 Los Angeles Olympics) and amateur basketball. She went on to win seven Women's Opens and three Titleholder's Championships.
12th June, 1951

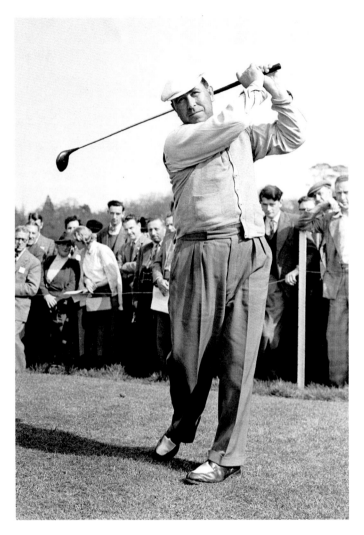

Irishman Harry Bradshaw at the Silver King Tournament at Moor Park. Bradshaw won the Irish PGA Championship ten times, the Irish Open twice, the British Masters twice and played in the Ryder Cup three times. He lost the 1949 British Open in a play-off against Bobby Locke.
17th April, 1952

Facing page: Peter Alliss playing in the Silver King Tournament at Moor Park. The son of the successful professional golfer Percy Alliss, Peter turned professional at the age of 16, in 1947, going on to win three British PGA Championships and participate in eight Ryder Cups, before becoming a popular television commentator.
18th April, 1952

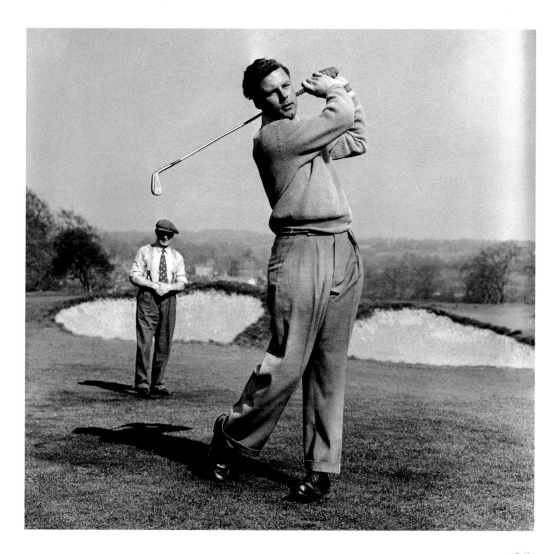

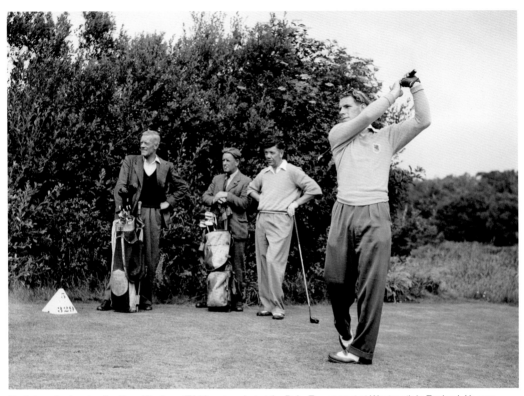

English professional golfer Harry Weetman (R) hits a tee shot at the Daks Tournament at Wentworth in England. He won many tournaments on the PGA tour, recording the lowest stroke average in 1952 and 1956, and played in seven Ryder Cups, captaining the team in 1965.

25th June, 1952

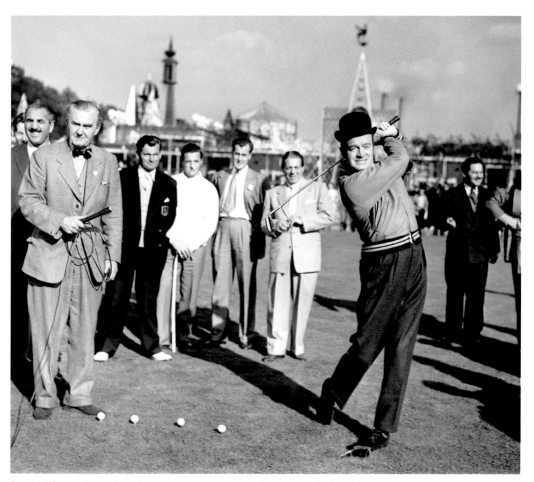

Popular US comedian and passionate golfer Bob Hope plays for laughs on the tee during the Miniature Golf Foursomes.
24th September, 1953

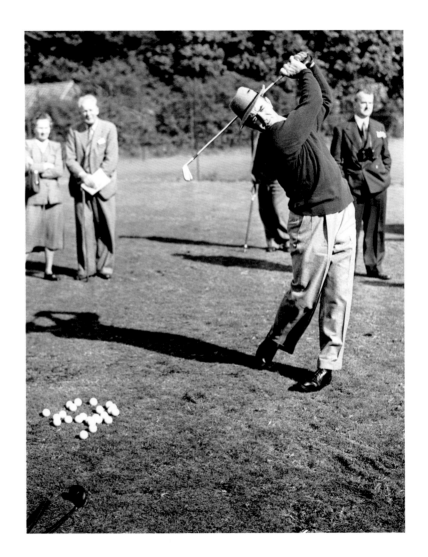

Sam Snead practises his iron shots on the driving range before the tenth Ryder Cup at Wentworth in England.
28th September, 1953

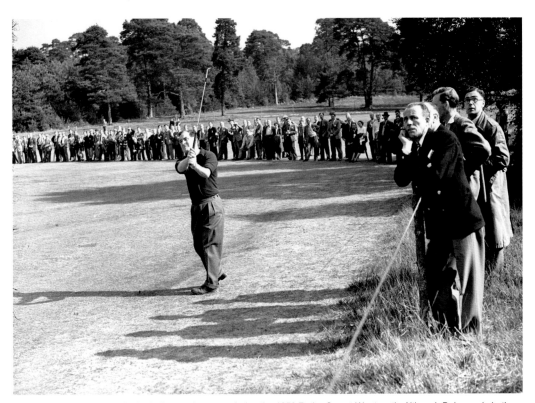

Great Britain's Fred Daly lofts the ball on to the green during the 1953 Ryder Cup at Wentworth. Although Daly won in both his foursome and his singles matches, the United States would go on to win the Cup by one point.
3rd October, 1953

Irishman Hugh Boyle's tee shot during the Open Assistant Professional Tournament, at Coombe Hill in England, is watched by (L–R) J.H. Ellis, F. Gould and P.D. Hedges. Boyle won three tournaments, as well as the 1967 Irish PGA Championship.
10th May, 1954

The USA team poses at St Andrews before the 1955 Walker Cup, the biennial tournament played between the leading amateur golfers of Britain and Ireland and the US: (L–R) Joe Patton, Joe Conrad, Don Cherry, Richard Yost, W. Campbell, E. Harvie Ward, James Jackson, Dale Morey, Bruce Cudd. The USA would go on to win comprehensively by ten points to two.
13th May, 1955

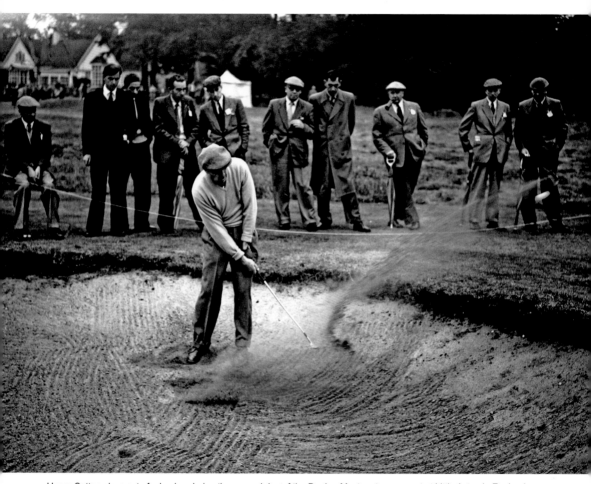

Henry Cotton plays out of a bunker during the second day of the Dunlop Masters tournament at Little Aston in England.
22nd September, 1955

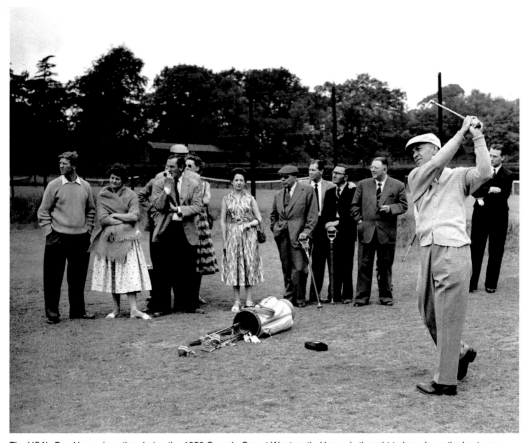

The USA's Ben Hogan in action during the 1956 Canada Cup at Wentworth. Hogan is thought to have been the best ever striker of the ball, thanks largely to his swing style and grip, which are still studied by golf enthusiasts to this day.
21st June, 1956

Bruce Crampton (L) in conversation with Dick Burton at the Spalding Tournament, Moor Park. An Australian, Crampton claimed 14 US PGA Tour wins, and was runner-up in four major championships – behind Jack Nicklaus each time.
24th April, 1957

Peter Alliss (L) looks on while Irishman Christy O'Connor Senior drives from the first tee at Moor Park. O'Connor won at least one major tournament each year during the 1960s and went on to be the leading Seniors player, winning the PGA Seniors Championship six times and the World Senior Championship in 1976 and 1977.
26th April, 1957

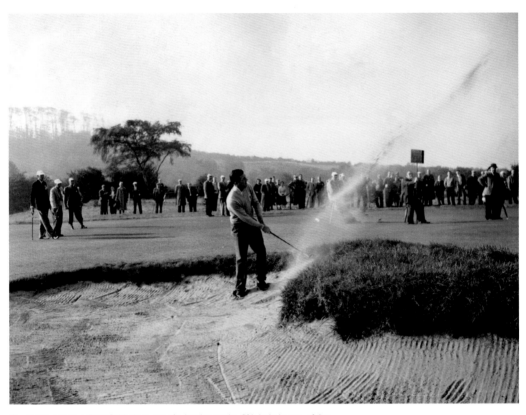

Great Britain's Ken Bousfield plays out of a bunker at the fifth hole in one of the opening foursome matches of the 12th Ryder Cup at Lindrick, Rotherham in England. Great Britain won by three points.
5th October, 1957

Facing page: Max Faulkner plays a rescue shot out of a bed of daffodils at Moor Park.
23rd April, 1958

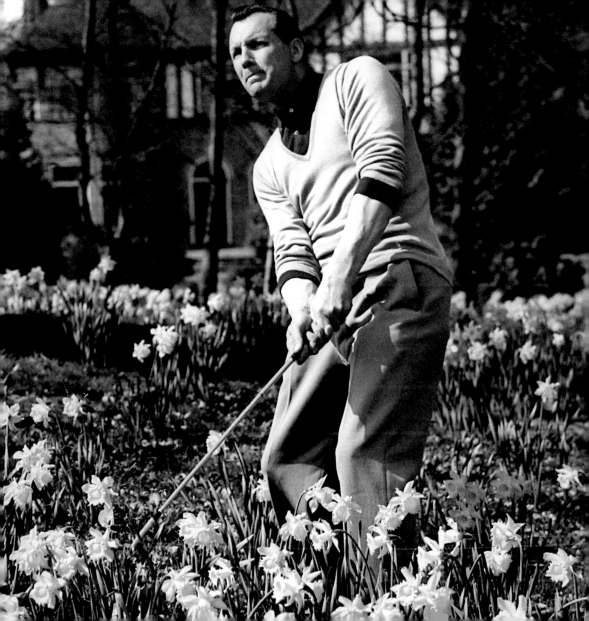

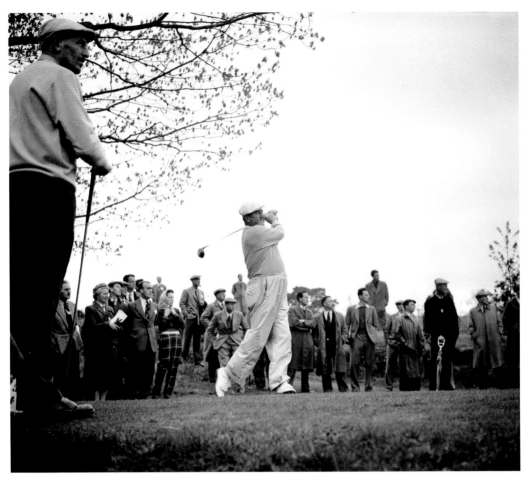

The crowd watch Bobby Locke's tee shot during the Dunlop Tournament at Wentworth.
6th May, 1958

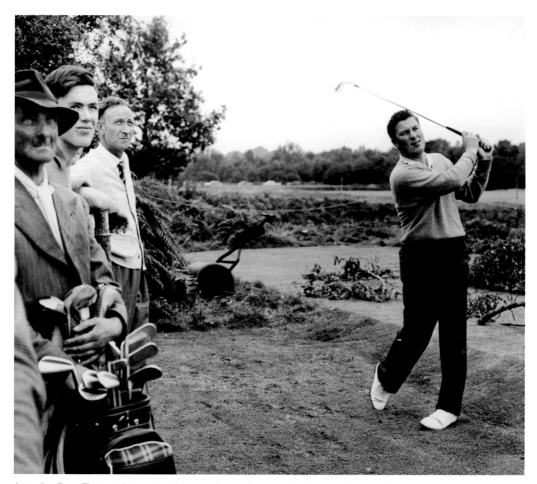

Australian Peter Thomson hits an iron shot in the *News of the World* Match Play Championship at Walton Heath.
9th September, 1958

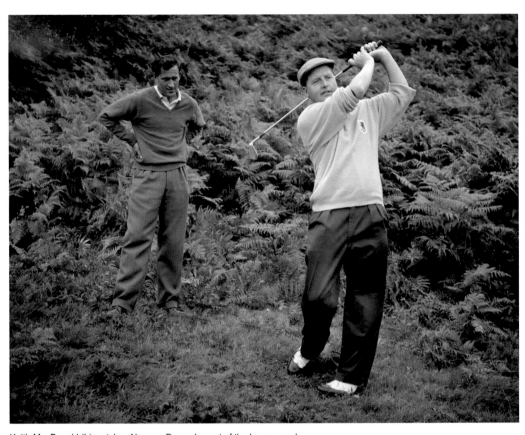

Keith MacDonald (L) watches Norman Drew play out of the heavy rough
during the Martini £3,000 Golf Tournament at The Berkshire Golf Club.
24th August, 1960

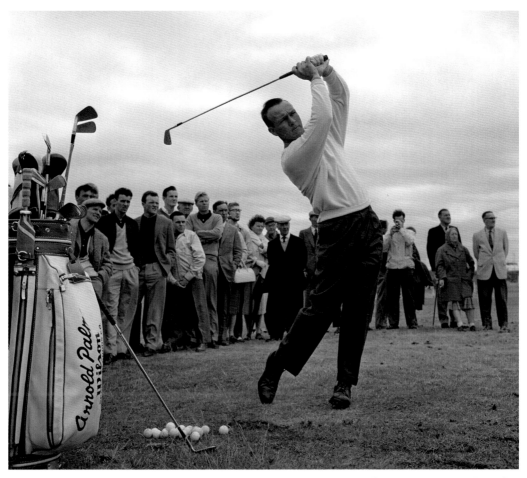

Arnold Palmer prepares for the British Open Golf Championship at the Royal Birkdale, at Southport in Lancashire, England.
10th July, 1961

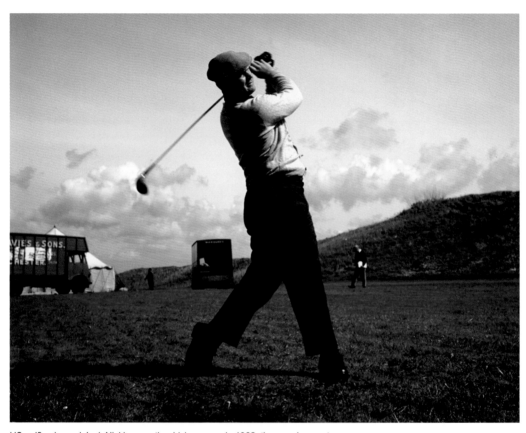

US golfing legend Jack Nicklaus on the driving range in 1962, the year he went professional and won his first US Open, beating Arnold Palmer in a play-off.
1st January, 1962

Facing page: After Henry Cotton retired from the game in the 1950s, he became a successful course designer.
1st June, 1962

HENRY COTTON

A
GEORGE NICOLL
PLAYER

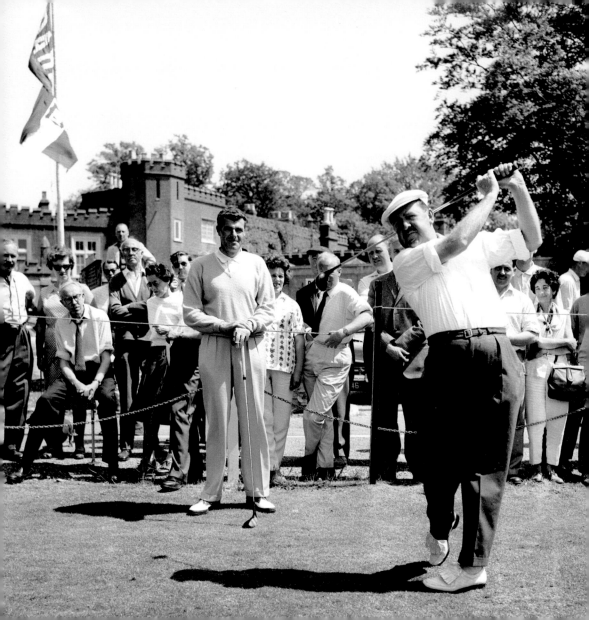

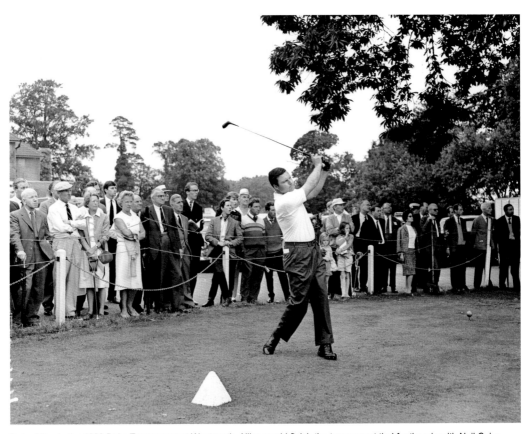

Peter Alliss in the 1963 Daks Tournament at Wentworth. Alliss would finish the tournament tied for the win with Neil Coles.
15th June, 1963

Facing page: Bobby Locke drives off the tee at the 1962 Daks
Tournament. He had won the Tournament in 1957.
7th June, 1962

Arnold Palmer enjoys a break during the 1963 British Open Championship at Royal Lytham & St Annes. He had won the previous year, but he failed to finish in the top 25. The event was won by New Zealander Bob Charles in a 36-hole play-off with American Phil Rodgers.

11th July, 1963

Facing page: Patty Berg was the leading US professional in the women's game during the 1940s, 1950s and into the 1960s.

28th August, 1963

Patty Berg was a founding member of
the US Ladies PGA Tour, and won an
incredible 15 titles, still a record in the
women's game.
28th August, 1963

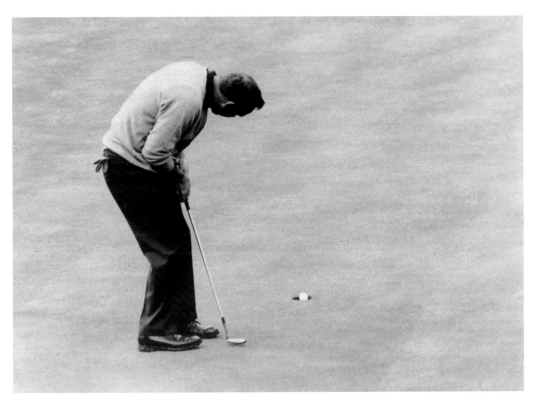

Arnold Palmer sinks a putt on the 16th green during the Piccadilly World Match Play Championship at Wentworth in England. Palmer went on to win the inaugural event, which has been held annually – albeit with different sponsors – ever since.
10th October, 1964

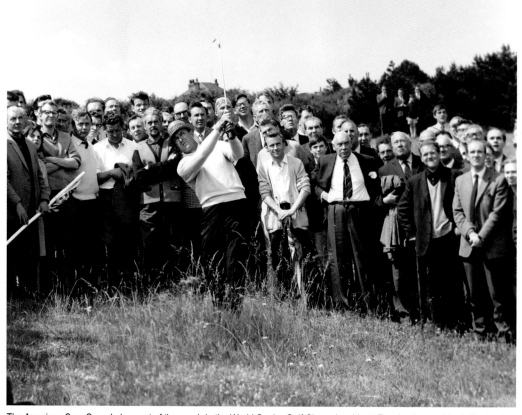

The American Sam Snead plays out of the rough in the World Senior Golf Championship at Formby, Lancashire in England.
5th July, 1965

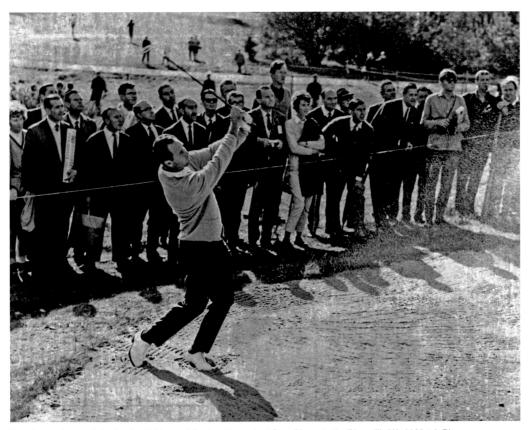

Tony Lema plays out of a bunker in his semi-final match against Gary Player in the Piccadilly World Match Play Championship.
15th October, 1965

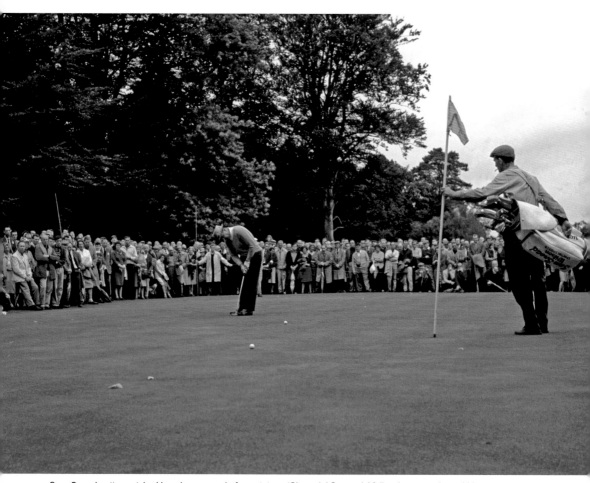

Sam Snead putts, watched by a huge crowd of spectators. 'Slammin' Sammy's' folksy image endeared him to many.
1st July, 1966

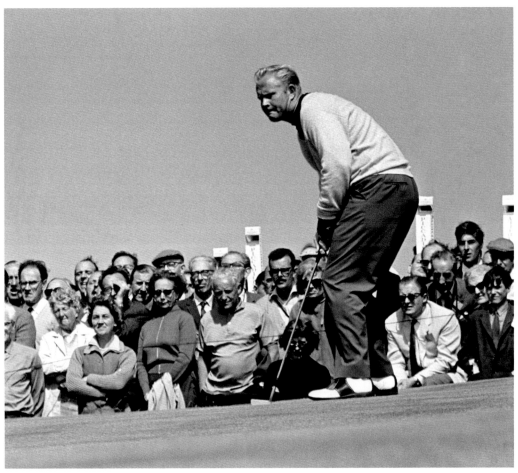

Jack Nicklaus on the fifth green in the Open Championship at Muirfield in Scotland. Fellow American Phil Rodgers won.
8th July, 1966

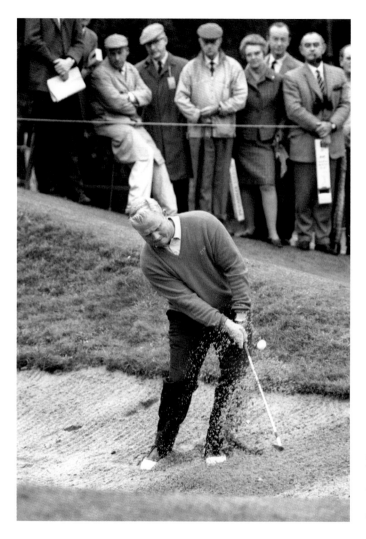

Jack Nicklaus plays out of a bunker on to the fifth green in the Piccadilly World Match Play Championship at Wentworth. Nicklaus would finish runner-up to Gary Player.
7th October, 1966

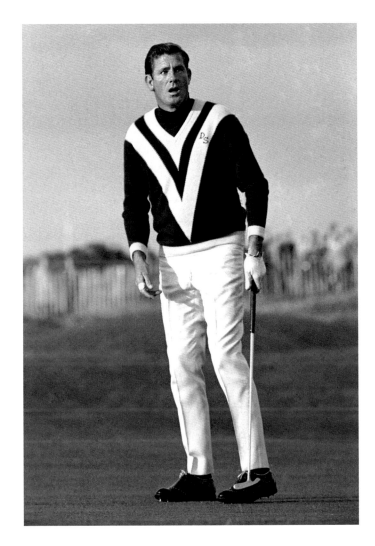

American Doug Sanders shows his relief as his putt drops into the hole on the 17th green during the Alcan Golfer of the Year Championship, at St Andrews in Scotland.

5th October, 1967

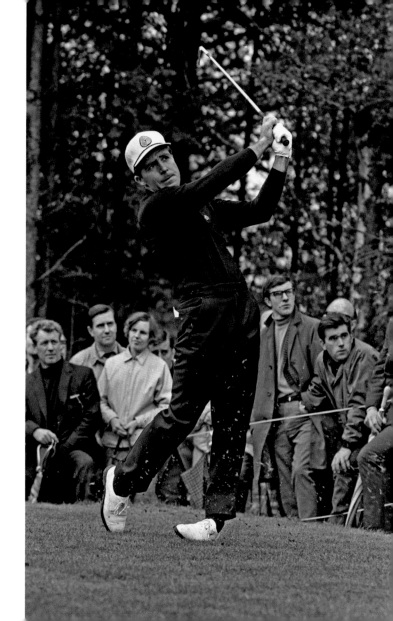

South African Gary Player in the
Piccadilly World Match Play
Championship at Wentworth. Player
won the event in 1965 and 1966 and
would win it another three times.
12th October, 1967

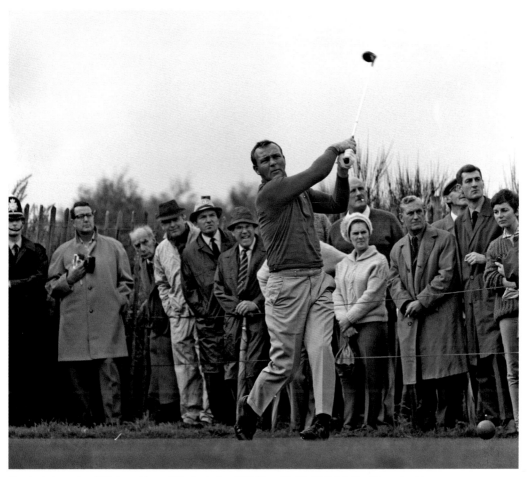

Eventual winner Arnold Palmer drives off the tee in the 1967 Piccadilly World Match Play Championship.
12th October, 1967

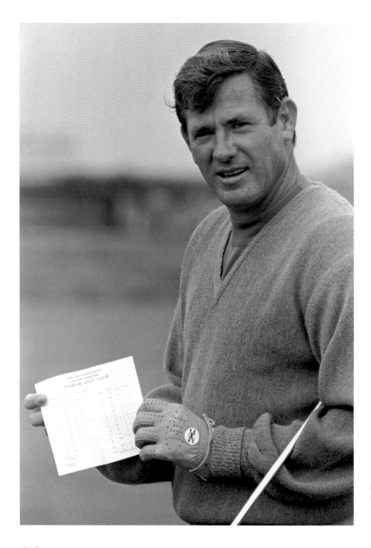

American Doug Sanders with his
qualification scorecard for the 1968
Open Golf Championship in Scotland.
10th July, 1968

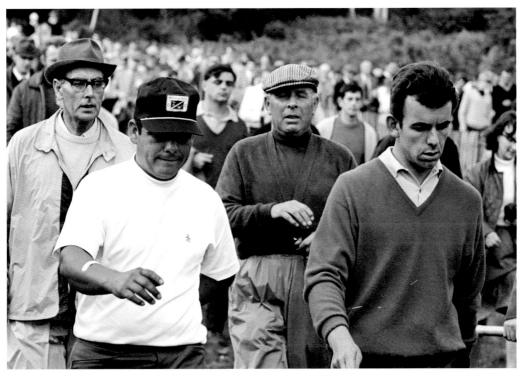

American Lee Trevino (L) and Englishman Tony Jacklin (R) walk to the next hole together during the Piccadilly World Match Play Championship. In the end, it was to be Gary Player's third Match Play win.
11th October, 1968

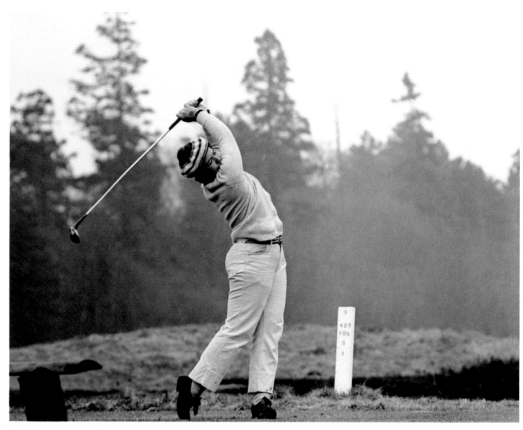

The French amateur Catherine Lacoste – daughter of the famous tennis player – hits a drive in the Avia Ladies' International Tournament. Lacoste won the 1967 US Women's Open as an amateur and won the US and British Ladies' Amateur Open in 1969, but she never turned professional.
20th March, 1969

Eddie Polland lines up a putt in the Daks Tournament. He won four European Tour events and the Irish PGA Championship.
30th May, 1969

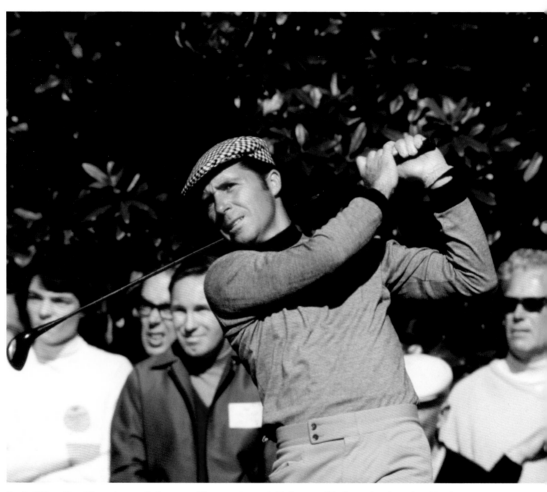

South African Gary Player is regarded as one of the game's greatest players, with nine major championship wins.
1st July, 1969

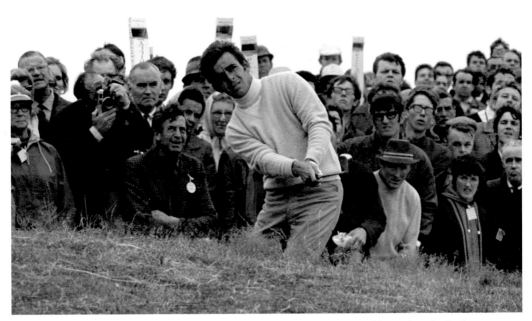

Tony Jacklin, the most successful British player of his generation, plays a chip shot out of the rough on the fourth green during the 1969 Open Championship at Royal Lytham & St Annes, which he would go on to win by a two-shot margin.
11th July, 1969

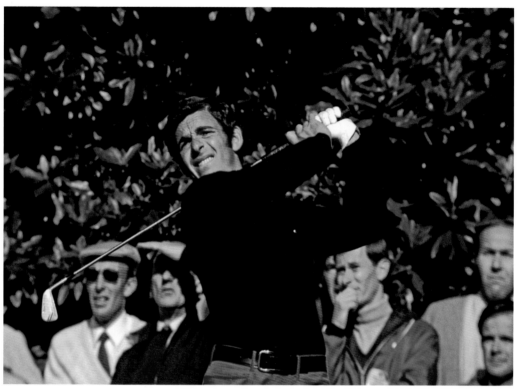

England's Tony Jacklin on his way to winning his first major title, the British Open.
He was the first British player to win the Open Championship for 18 years.
11th July, 1969

Facing page: Gary Player in the British
Open at Royal Lytham & St Annes.
12th July, 1969

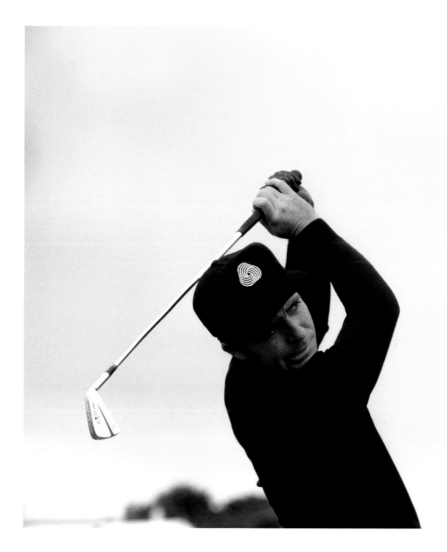

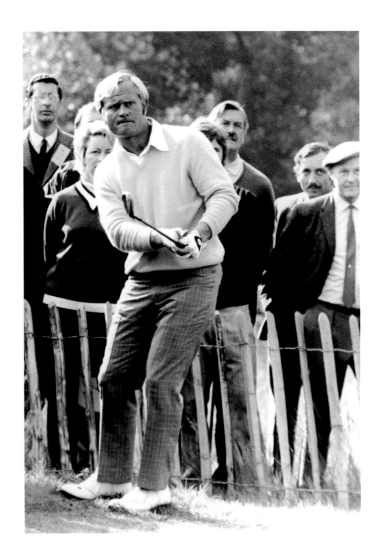

Jack Nicklaus in the Piccadilly World
Match Play Championship at
Wentworth, which he won ahead of
fellow American Lee Trevino.
9th October, 1970

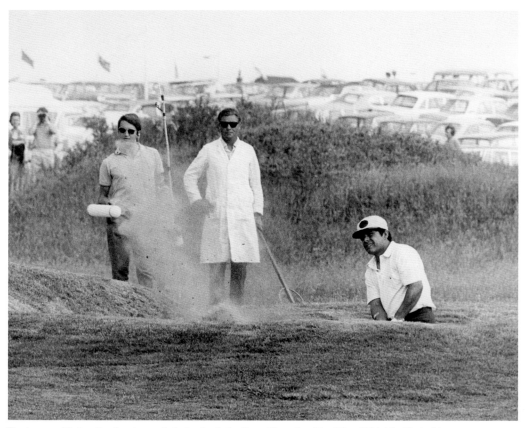

The irrepressible Lee Trevino plays out of a bunker in the Open Championship at Royal Birkdale. Masterful recovery shots like this would see Trevino eventually win the event by just one shot from the Taiwanese Liang-Huan Lu.
8th July, 1971

Liang Huan Lu won many admirers with his second round 70 in the 1971 Open Golf Championship at Royal Birkdale.

8th July, 1971

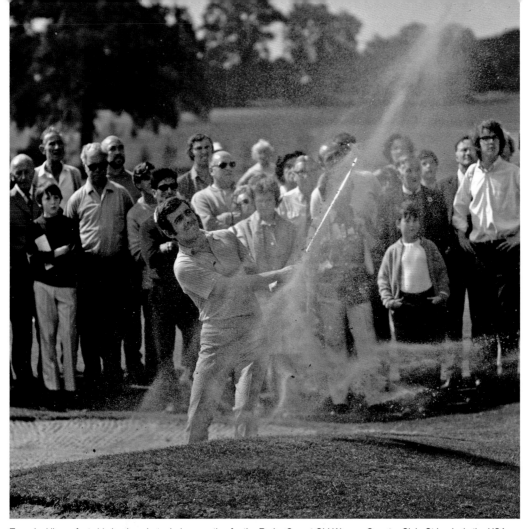

Tony Jacklin perfects his bunker shots during practice for the Ryder Cup at Old Warson Country Club, St Louis, in the USA.
5th September, 1971

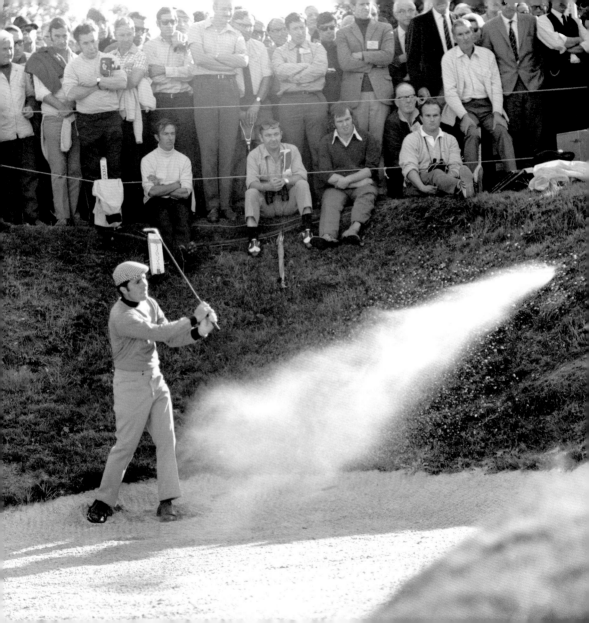

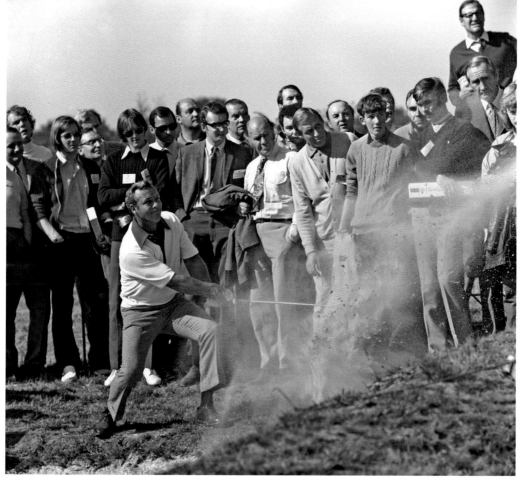

Facing page: Gary Player fires his ball
out of the sand on his way to a fourth
World Match Play win at Wentworth.
7th October, 1971

Arnold Palmer also found the bunkers
during the Piccadilly World Match Play
Championship at Wentworth.
7th October, 1971

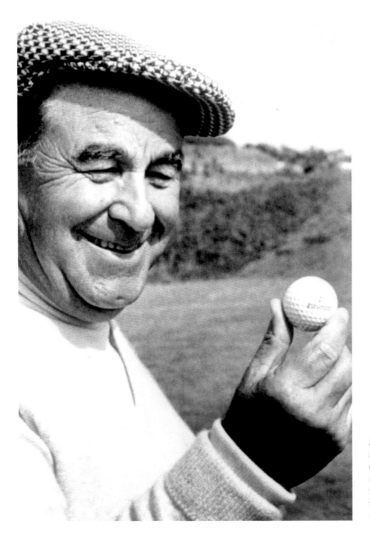

American veteran Gene Sarazen admires the ball with which he holed out in one at the 126-yard eighth in the Open Championship at Troon. A former title holder, he was then 71 and the oldest player in the competition.
11th July, 1973

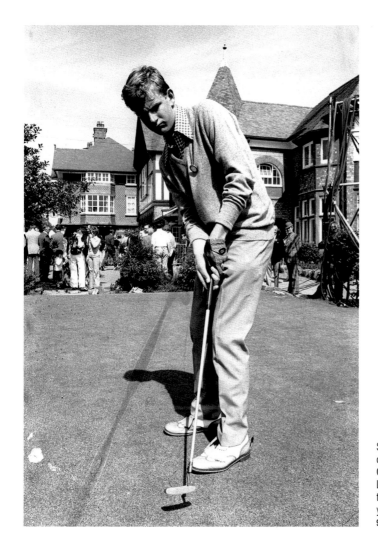

Sandy Lyle, at 16, the youngest competitor in the Open Golf Championship, held at the Royal Lytham & St. Anne's. He would win the British Open at Sandwich 11 years later in 1985.
9th July, 1974

American Tom Watson after beating Australian Jack Newton to win the Open Golf Championship at Carnoustie, Scotland.
1st July, 1975

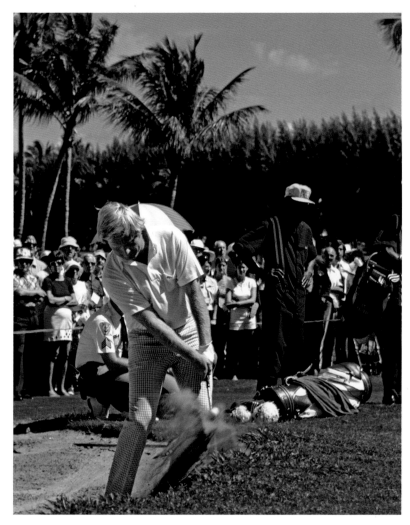

Jack Nicklaus plays out of
the bunker at Lauderhill,
Florida, in the USA,
during the 1976 Players
Championship, which
he won that year.
1st March, 1976

South Africa's Gary Player drives off
the first tee at the Penfold PGA
Championship at Sandwich, England.
31st May, 1976

Arnold Palmer lines up a putt at the British Open at Royal Birkdale. He would eventually tie for second place in the Championship with the rising Spanish star Seve Ballesteros.

7th July, 1976

Arnold Palmer uses a wood to play a
difficult shot off the road during The
Open Championship at Royal Birkdale.
7th July, 1976

The winner of the Open Championship 1976, top American golfer Johnny Miller, takes a break during his final round at Royal Birkdale. He beat Palmer and Ballesteros to the title by an impressive margin of six strokes.
10th July, 1976

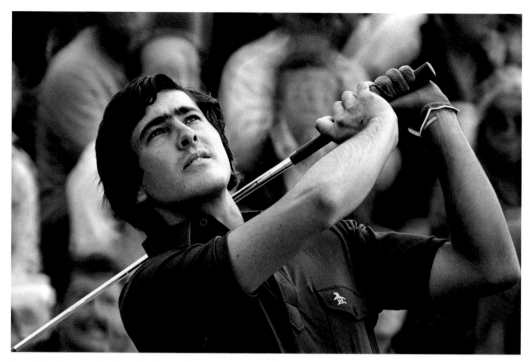

Seve Ballesteros watches his lofted iron shot during the last round of the Open Championship, at Royal Birkdale. The 19-year-old Spaniard made his mark on the world golf stage during the tournament, finishing tied for second after a miraculous chip shot on to the green of the 18th hole between two bunkers.
10th July, 1976

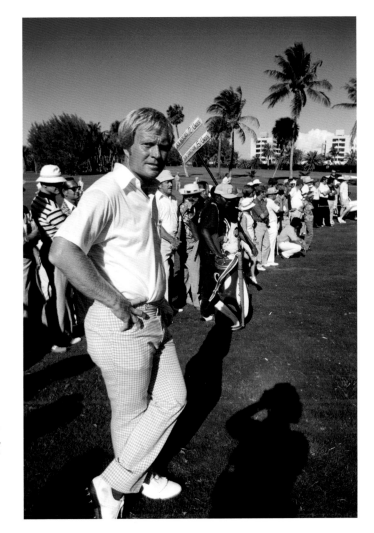

Nineteen-seventy-six proved to be an unusually lean year for Jack Nicklaus, with only two event wins out of the 16 he entered, although he again placed first on the PGA Tour money list. He also won the PGA Player of the Year award for a record fifth time.

1st August, 1976

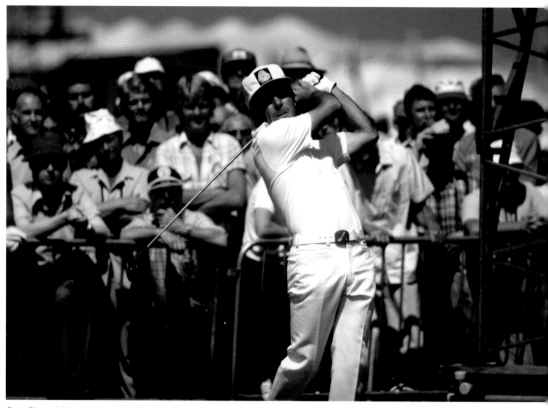

Gary Player hits a drive, watched by the crowds that turned out in the sunshine, during Turnberry's first British Open in 1977.
7th July, 1977

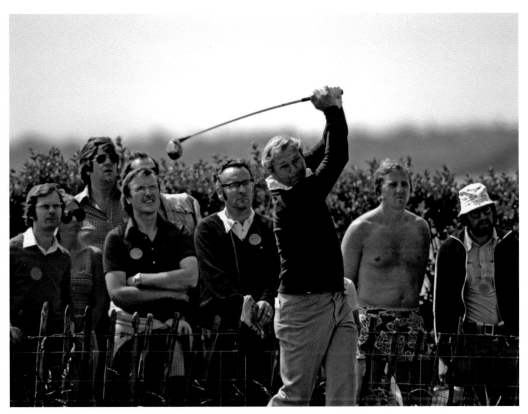

Arnold Palmer drives from the second tee in the Open Championship at Turnberry.
7th July, 1977

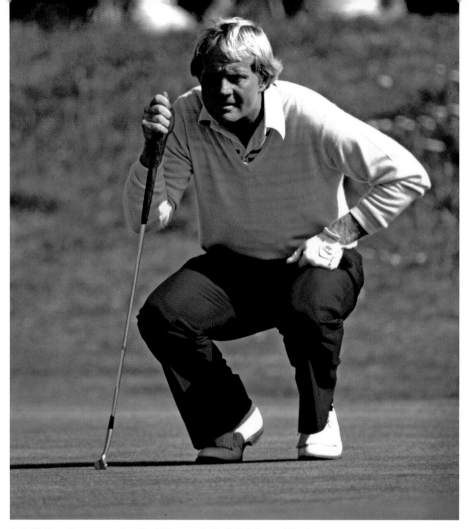

Jack Nicklaus lines up a putt on the 15th green in the British Open at Turnberry.
7th July, 1977

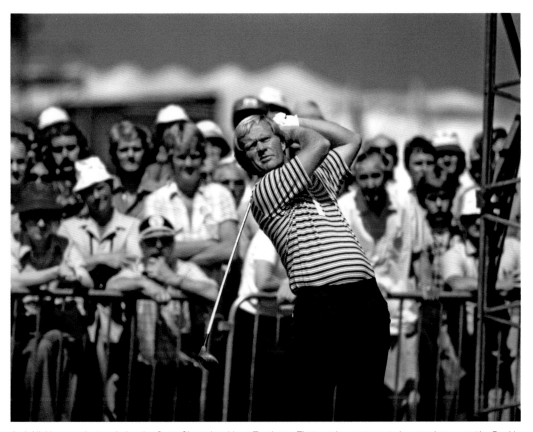

Jack Nicklaus on the tee during the Open Championship at Turnberry. That year's event was to become known as 'the Duel in the Sun', as Nicklaus and Tom Watson fought for the lead in the heat. Watson finally won by one stroke on the last green.
10th July, 1977

Debbie Austin and her caddy take a
break during the Ladies PGA
Championship at Sunningdale,
in England.
4th August, 1977

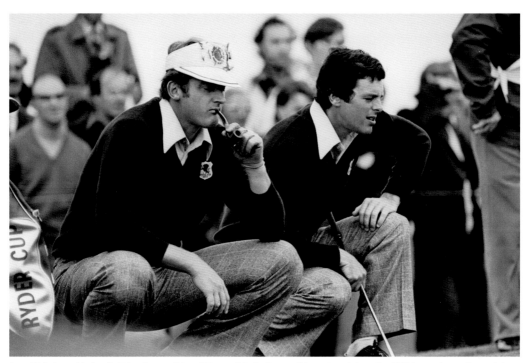

Great Britain and Ireland's Brian Barnes (L) and Bernard Gallacher can't bear to watch as the USA team win another point in the 22nd Ryder Cup played at Royal Lytham & St Annes. The United States dominated each day and won by five points. From 1979, both sides agreed that leading players from continental Europe would also be eligible to play against the USA.
17th September, 1977

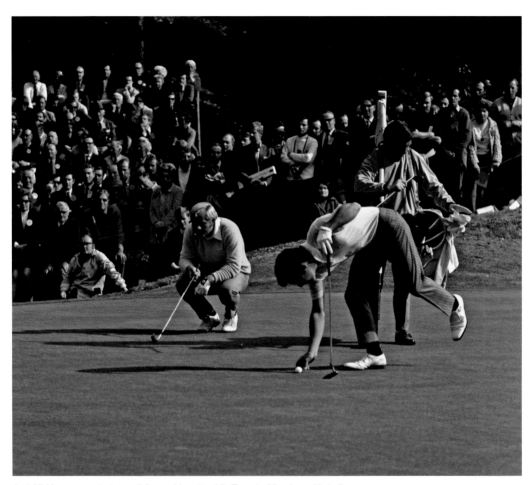

Jack Nicklaus concentrates on lining up his putt, while Tony Jacklin places his ball during the 1977 Colgate World Match Play Championship at Wentworth.
9th October, 1977

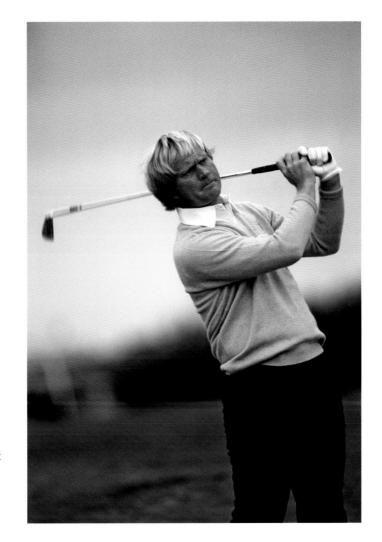

1977 would again prove to be a
majorless year for Jack Nicklaus, but
he won his 63rd PGA Tour event,
passing Ben Hogan to take second
place on the career wins list, behind
only Sam Snead.
10th October, 1977

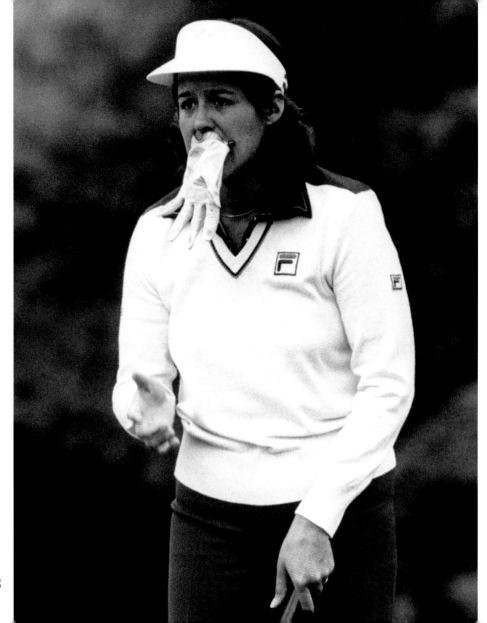

Tom Watson seems happy enough with his first-round score of 68 (three under) during the 1980 Open Golf Championship at Muirfield in Scotland. The popular American would go on to win the event that year for the third time.
17th July, 1980

Facing page: Nancy Lopez holds her glove in her mouth during the Colgate Ladies' Tournament at Sunningdale.
4th August, 1979

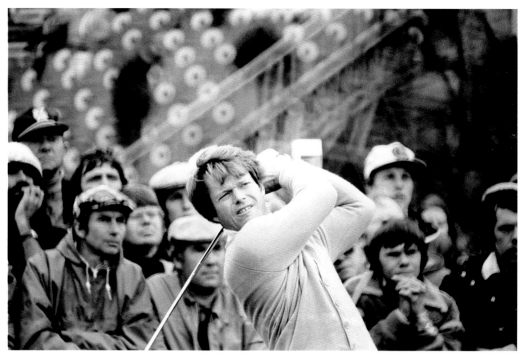

Tom Watson in the Open Golf Championship at Muirfield. He beat fellow American Lee Trevino by four shots.
20th July, 1980

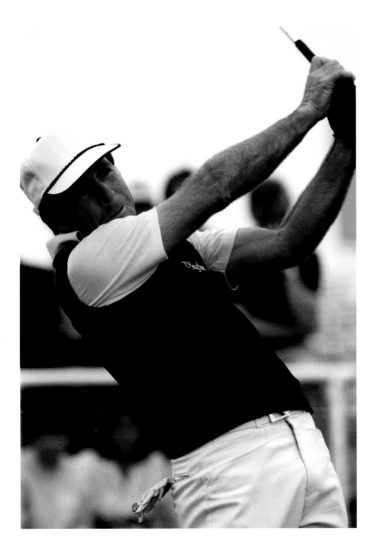

Gary Player in full flow on the Royal
St George's golf course in Sandwich
for the Open Championship.
7th July, 1981

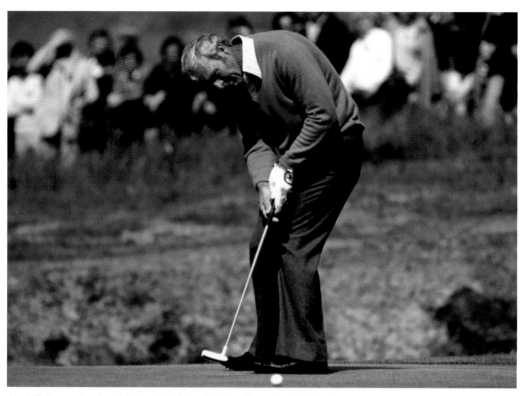

Arnold Palmer anxiously watches his putt during the Open Championship played at the Royal St George's golf club in Sandwich. The event was won that year by the American Bill Rogers.

7th July, 1981

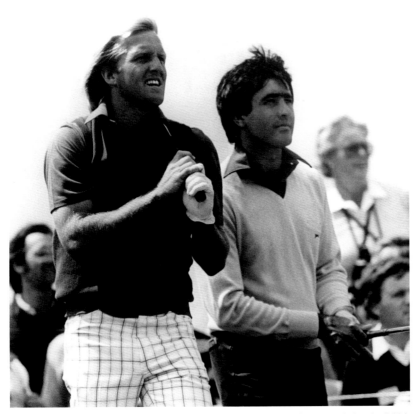

Greg Norman (L) and Seve Ballesteros look down the fairway from the fourth tee during the British Open at Sandwich.
18th July, 1981

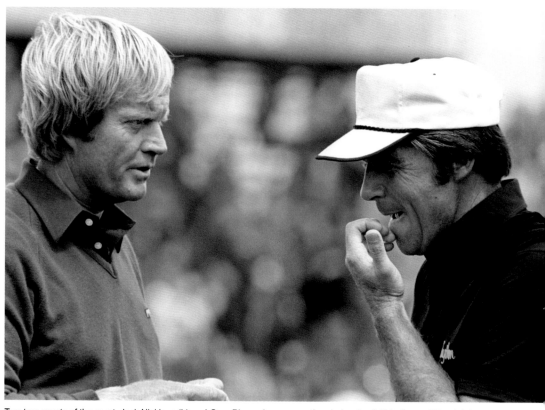

Two true greats of the sport, Jack Nicklaus (L) and Gary Player, in conversation during the British Open at Sandwich.
18th July, 1981

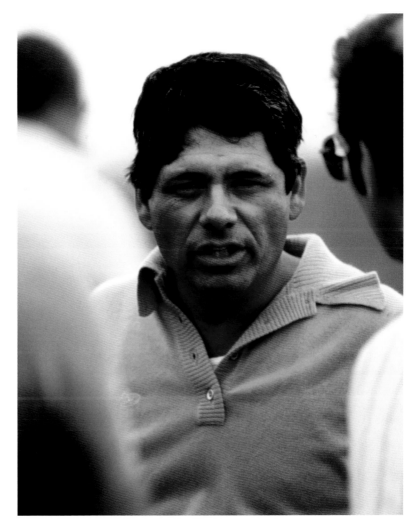

Lee Trevino during the British Open in 1981. The American won the event in two consecutive years, in 1971 and 1972, a feat only subsequently repeated by Tom Watson, Tiger Woods and Padraig Harrington.

18th July, 1981

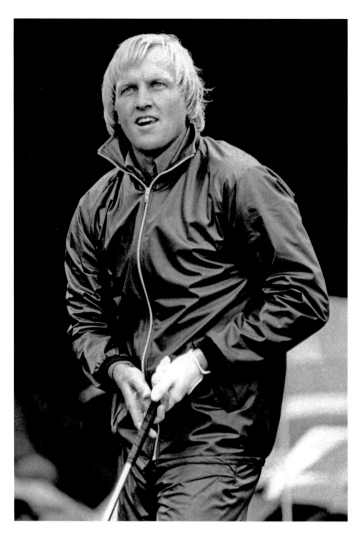

Australian Greg Norman watches his ball during the Bob Hope Classic at Moor Park.

26th September, 1981

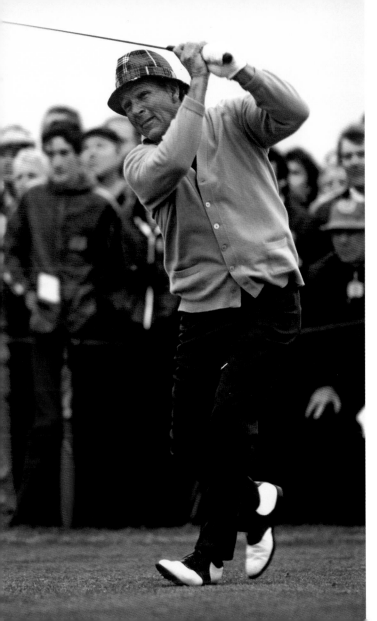

Arnold Palmer playing in the British
Open at Royal Troon in Scotland.
1982

Tony Jacklin (L) and Jack Nicklaus walk to the next tee in the Open Championship held at Royal Troon.
July, 1982

Facing page: Bernard Gallacher focuses on a putt in the British Open.
6th July, 1982

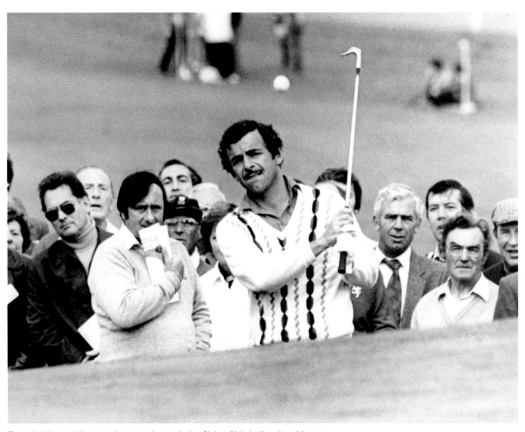

Tony Jacklin and the crowd nervously watch the flight of his ball as he chips out
of a bunker and on to the green in the Bob Hope Classic, held at Moor Park.
23rd September, 1982

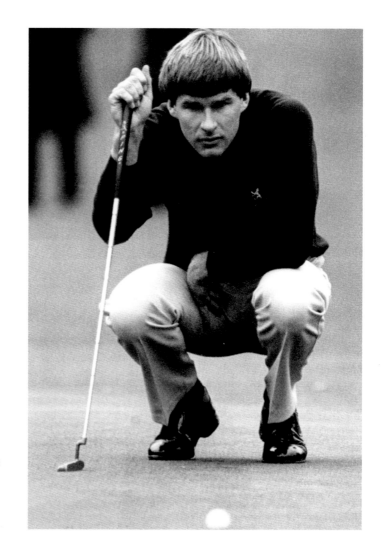

Nick Faldo carefully chooses his line on the green in the Suntory World Match Play Championship at Wentworth. The Spaniard Seve Ballesteros would win the event.
14th November, 1982

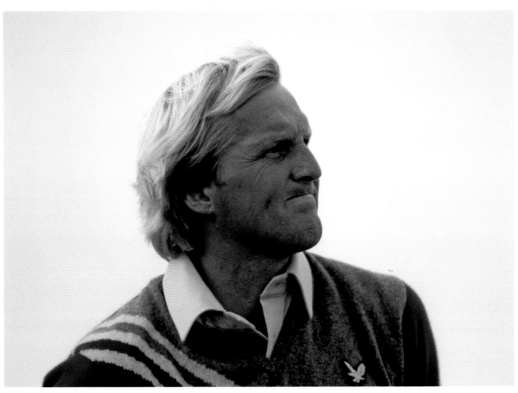

Greg Norman watches his shot at the Open Championship at St Andrew's. The Australian would finish seventh.
22nd July, 1984

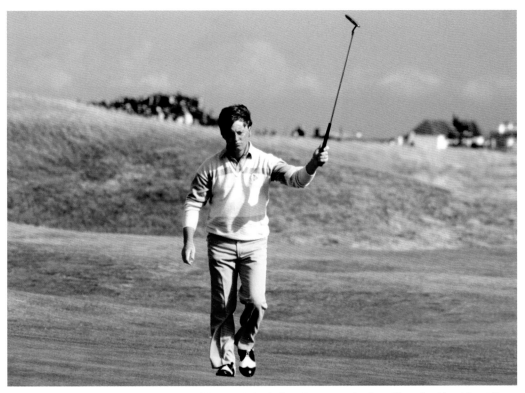

Ian Woosnam acknowledges the appreciation of the crowd after holing a long putt at the Open Championship, at Royal St George's, in England. The event would be won by the Scot, Sandy Lyle.
12th July, 1985

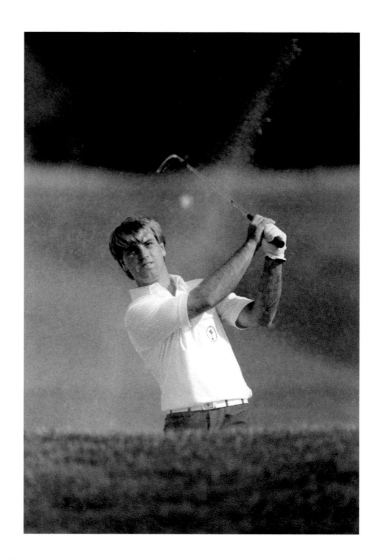

Europe's Paul Way during practice
before the 26th Ryder Cup, held at
The Belfry, in England.
12th September, 1985

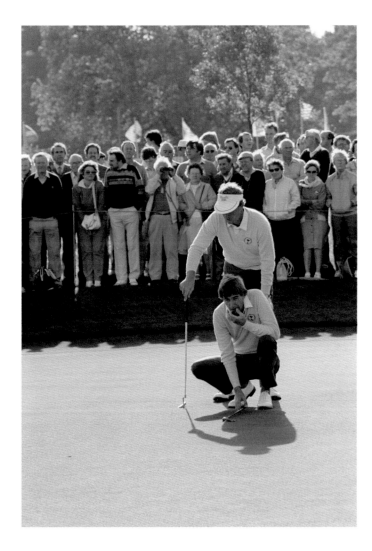

Ken Brown (bottom) benefits from Sandy Lyle's advice on the fifth green during the Ryder Cup at The Belfry. Europe, captained by Tony Jacklin, won for the first time. It was the first time USA had lost the cup since 1957.
13th September, 1985

Tom Watson at the Open Championship at Muirfield, Scotland, in 1987, 12 years after his first win. Watson had made the Open almost his second home, winning five times, and would finish a respectable seventh this time.
14th July, 1987

Facing page: Nick Faldo rests his feet after scoring a three-under-par 68 in the first round of the British Open.
16th July, 1987

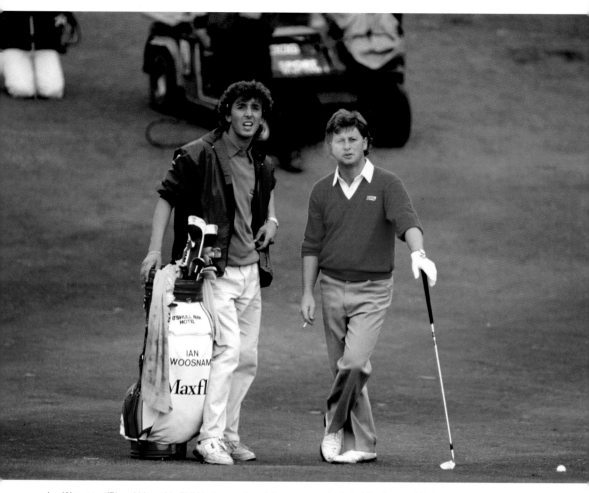

Ian Woosnam (R) and his caddy Phil Morbey contemplate an approach shot at the Suntory World Match Play Championship.
19th October, 1987

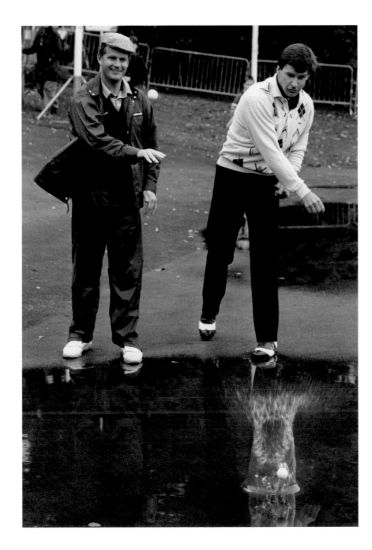

Suntory World Match Play
Championship finalists Sandy Lyle (L)
and Nick Faldo try skimming golf balls
in one of the many puddles at
Wentworth after play was postponed
due to torrential rain.
9th October, 1988

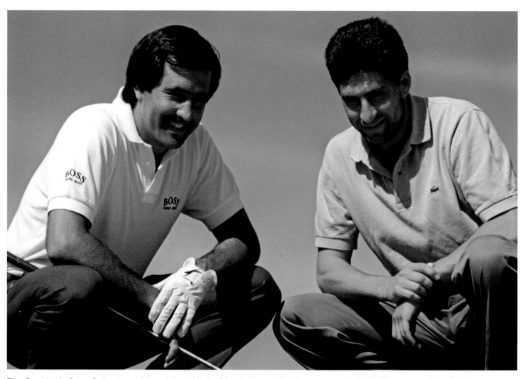

The Spaniards Seve Ballesteros (L) and Jose Maria Olazabal pose for the cameras in 1990. The young Olazabal was emerging as a major new talent, and would go on to win two US Masters titles in 1994 and 1999.
1990

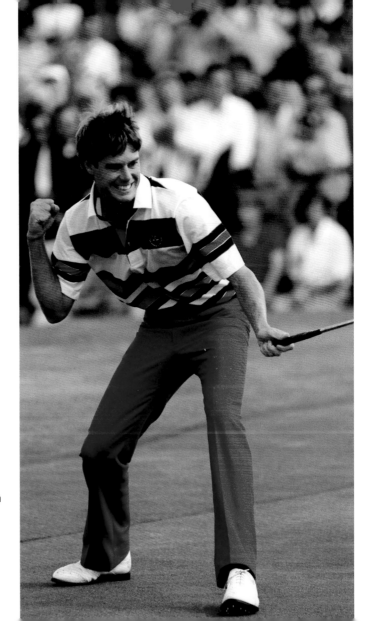

Paul Azinger celebrates a successful putt. The American would win 11 tournaments on the PGA Tour in seven seasons from 1987 to 1993, climaxing in his one major title, the 1993 PGA Championship.
11th June, 1990

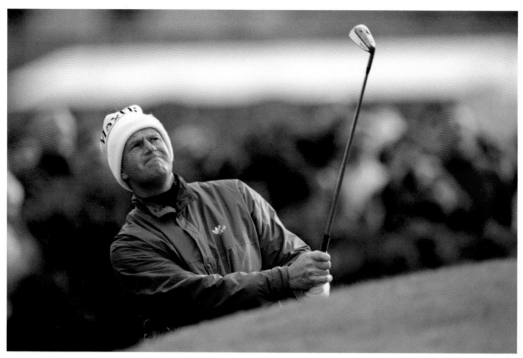

Sandy Lyle seems less than happy with his chip shot during the Alfred Dunhill Cup at the Old Course, St Andrews in Scotland.
16th October, 1992

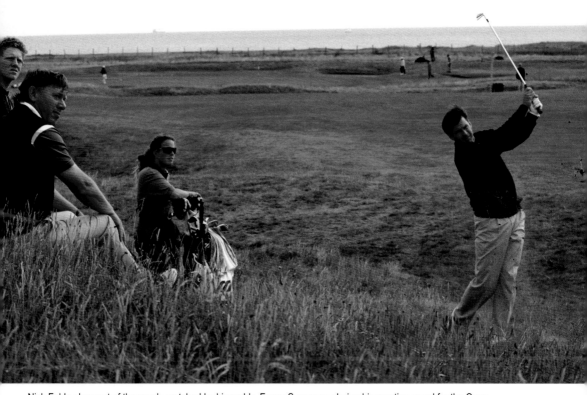

Nick Faldo plays out of the rough, watched by his caddy, Fanny Sunesson, during his practice round for the Open Championship held at Royal St George's. Faldo would finish second to Greg Norman.
13th July, 1993

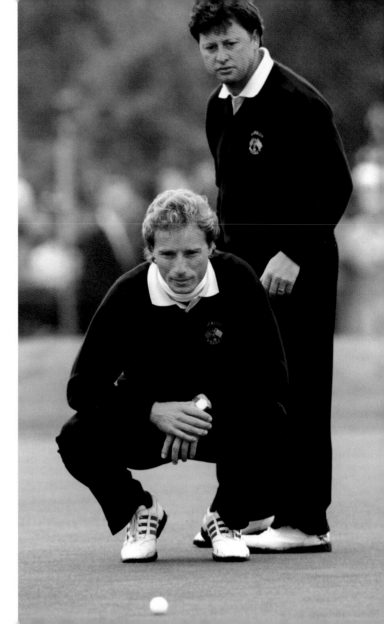

Europe's Bernhard Langer (L) and Ian
Woosnam contemplate the next putt in
the 1993 Ryder Cup at The Belfry.
23rd September, 1993

128

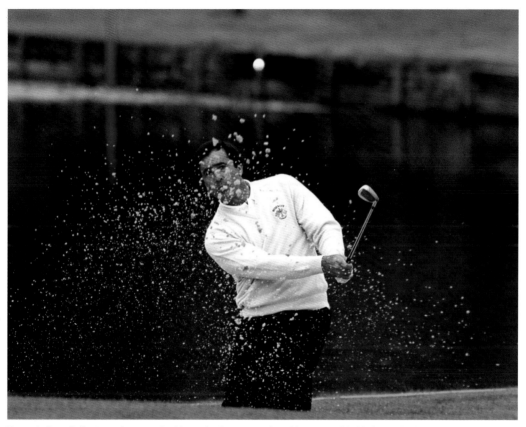

Europe's Seve Ballesteros demonstrates his genius for escape play with a masterful chip from a bunker on to the green.
23rd September, 1993

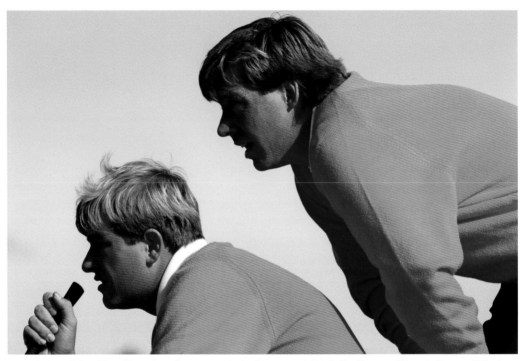

Europe's Peter Baker (L) and Barry Lane line up a putt in the foursomes at The Belfry. They would lose to Raymond Floyd and Payne Stewart, and USA would eventually win the Ryder Cup by two points, 15 points to 13.

25th September, 1993

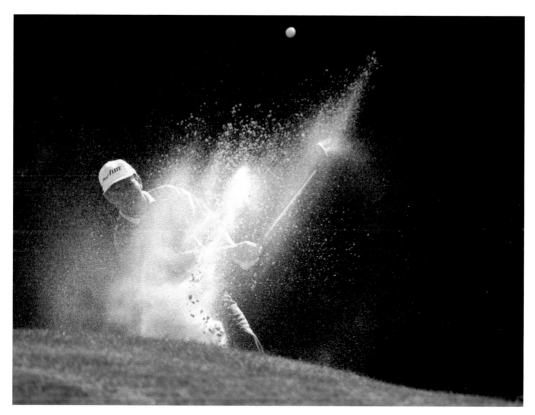

Ronan Rafferty explodes his ball from the sand. The Northern Irishman finished top of the European Tour Order of Merit in 1989 and came close to breaking the record for consecutive cuts made on the European Tour in the early 1990s, but he began to struggle for form and suffered a number of injuries later that decade.
29th May, 1995

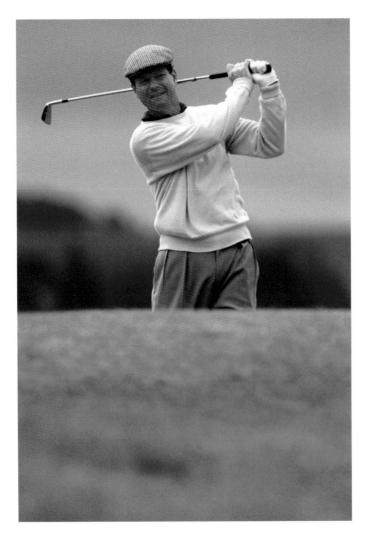

Tom Watson plays on to the green in the Open Championship at St Andrews. The American last won the event in 1983, a record fifth British Open title.
20th July, 1995

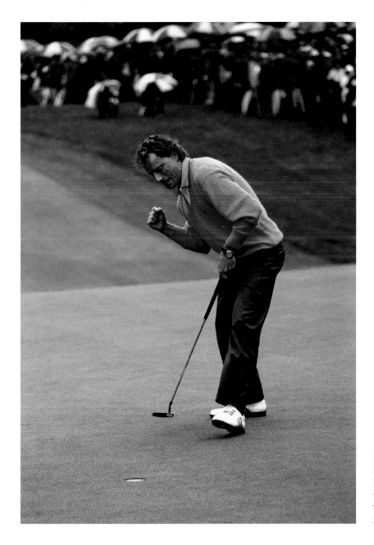

Europe's Bernhard Langer celebrates holing his putt on the 18th and winning his match in the Ryder Cup at Oak Hill Country Club in the USA. Europe would win by one point.
22nd September, 1995

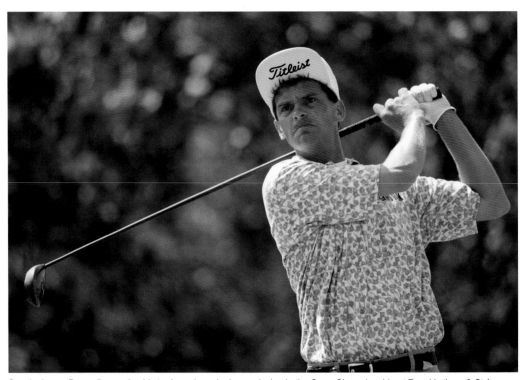

Swede Jesper Parnevik, wearing his trademark peaked cap, playing in the Open Championship at Royal Lytham & St Annes. The event was won by American Tom Lehman, two strokes clear of Ernie Els and Mark McCumber.

19th July, 1996

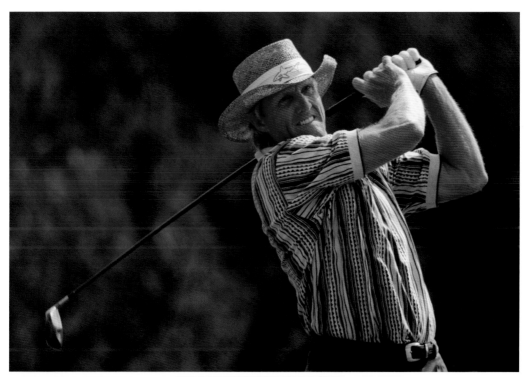

Australian Greg Norman during his second round at the 126th Open Championship at Royal Troon.
18th July, 1997

American Brian Watts chips out
of a bunker at the 18th, watched
by a TV cameraman, in the Open
Championship at Royal Birkdale.
19th July, 1998

Englishman Justin Rose contemplates
his drive from the second tee during
the Open Championship at Royal
Birkdale. Rose would finish in fourth.
19th July, 1998

France's Jean Van De Velde plays out of trouble on to the second green during the Open Championship at Carnoustie, in Scotland.
18th July, 1999

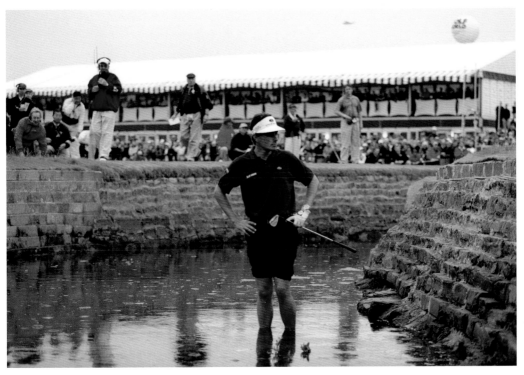

The 1999 Open will be remembered for the way Jean Van De Velde lost a three-stroke lead and the play-off to Scotsman Paul Lawrie on the final hole. Here the Frenchman stands in the brook after putting his ball in the water on the 18th.
18th July, 1999

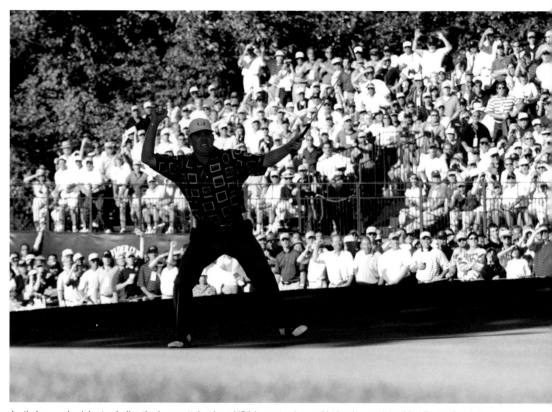

Justin Leonard celebrates holing the long putt that kept USA in contention and helped to seal the 33rd Ryder Cup for the Americans after a remarkable comeback on the final day at The Country Club, Brookline in Massachusetts, USA.
26th September, 1999

Tiger Woods practises for the Open Championship at St Andrews. The American dominated the 2000 British Open, hitting 60s all four rounds, and won by a final margin of eight strokes over Thomas Bjorn and Ernie Els.
19th July, 2000

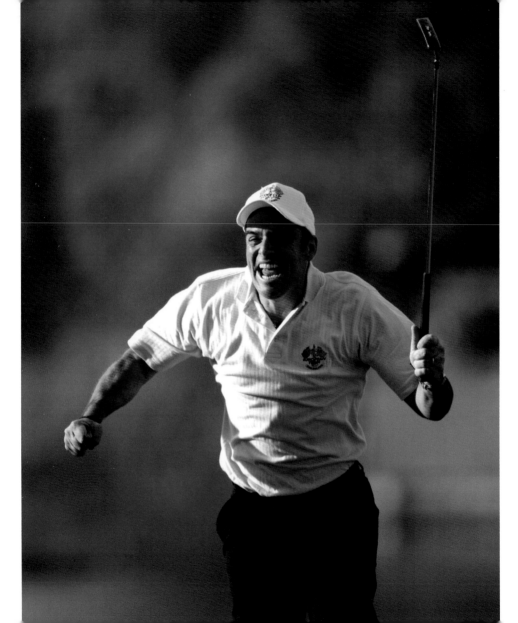

Ian Poulter shows off his eye-catching haircut during practice for the Nissan Irish Open at Portmarnock in Dublin. The young Englishman was an emerging talent, winning a European Tour event each year from 2000 to 2002, and two events in 2003.
22nd July, 2003

Facing page: Europe's Paul McGinley celebrates winning the 34th Ryder Cup held at The Belfry.
29th September, 2002

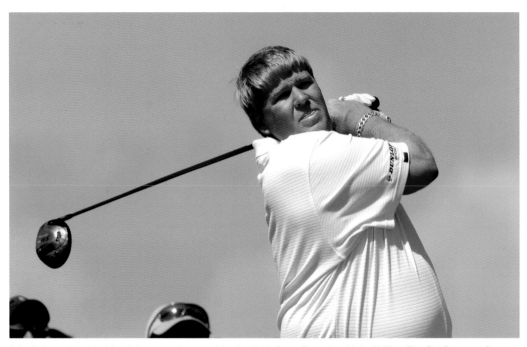

John Daly watches his drive during a practice round for the 134th Open Championship in 2005 on The Old Course at St Andrews. The American put on a spirited show, but finished well behind the leaders.

12th July, 2005

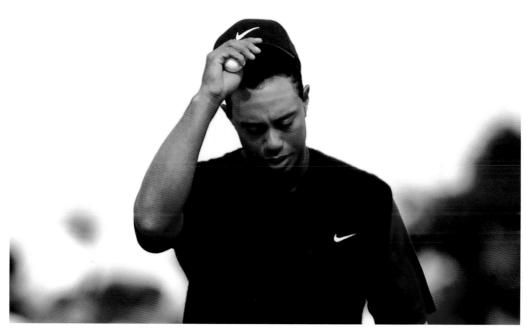

Tiger Woods acknowledges the crowd as he walks up the fairway on the last day of play. The American again dominated the 134th British Open, as he had the last time it was played at St Andrews, and he finished five shots clear of the runners-up.
17th July, 2005

USA's precocious talent Michelle Wie playing in the Women's British Open at Royal Birkdale in 2005, aged 15. Wie became the youngest ever player to qualify for a USGA amateur championship, at the tender age of ten, in 2000. She turned professional on 5th October, 2005, one week before her 16th birthday.

28th July, 2005

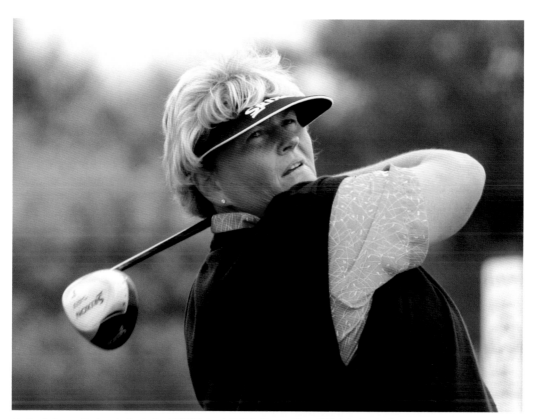

England's Laura Davies playing in the 2005 Women's British Open at Royal Birkdale. Davies is the most accomplished English female golfer of her generation and the first non-American to finish at the top of the LPGA money list. She has recorded 81 professional wins, 20 of which are on the LPGA Tour, including four majors.
30th July, 2005

Scotland's Colin Montgomerie during the final round of the Dunhill Links
Championships at St Andrews, which he won by one stroke ahead of
Englishman Kenneth Ferrie.
2nd October, 2005

Facing page: Juli Inkster lines up a
putt with her caddy during the first
round of the Weetabix Women's Open
at Royal Lytham & St Annes.
3rd August, 2006

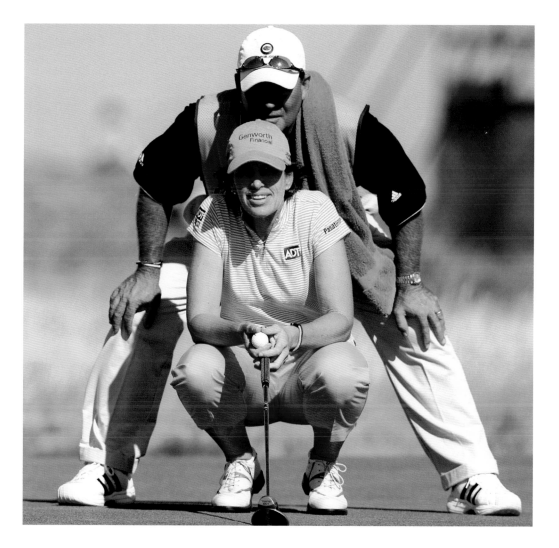

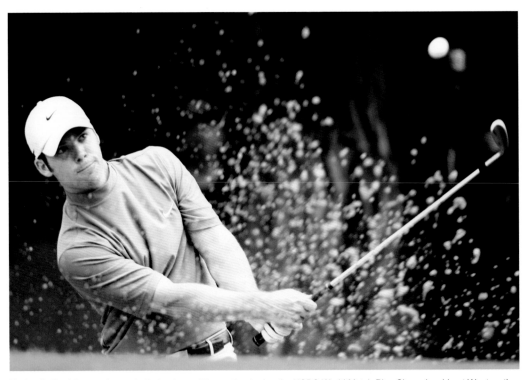

England's Paul Casey plays out of a bunker on his way to winning the HSBC World Match Play Championship at Wentworth by the largest ever margin of victory in its 43-year history, defeating US golfer Shaun Micheel by a 10 and 8 margin.
15th September, 2006

USA Ryder Cup players, Jim Furyk (L) and Tiger Woods, on the practice green, prior to their final practice round at the K Club, County Kildare in Ireland, ahead of the 36th Ryder Cup, which Europe would go on to win by a nine-point margin.
21st September, 2006

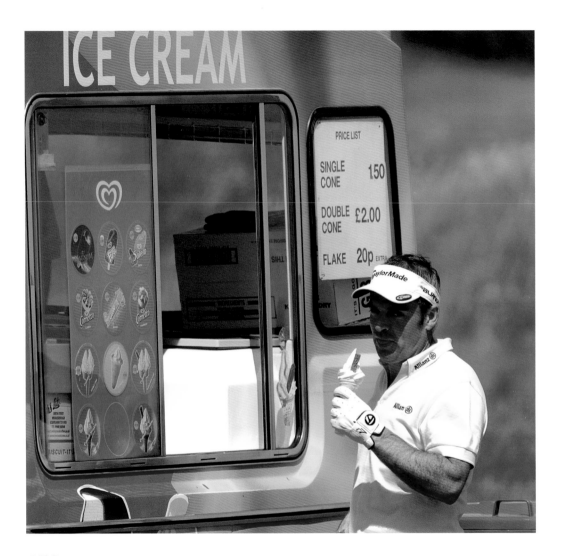

The American Mark Calcavecchia in action during a practice day ahead of the Open Championship at Carnoustie. He had won the British Open at The Troon in 1989.
18th July, 2007

Facing page: Paul McGinley enjoys an ice cream between practice rounds ahead of the British Open at Carnoustie.
17th July, 2007

Europe's Miguel Angel Jimenez is
disconsolate after missing a putt on
the 17th hole of his last day singles
match, enabling the USA to win the
37th Ryder Cup at Valhalla Golf Club,
Louisville, USA.
21st September, 2008

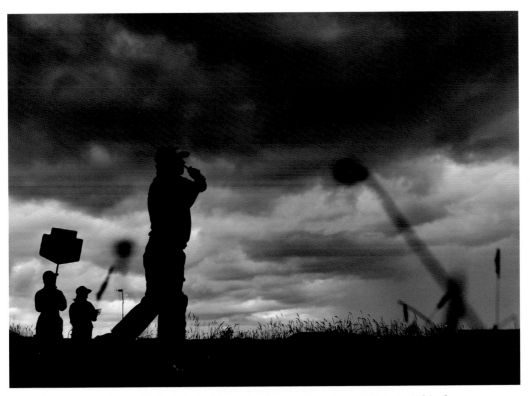

England's Lee Westwood tees off in front of a backdrop of looming rain clouds during the first round of the Open Championship on the Old Course at St Andrews. Westwood would finish second behind South African Louis Oosthuizen.
15th July, 2010

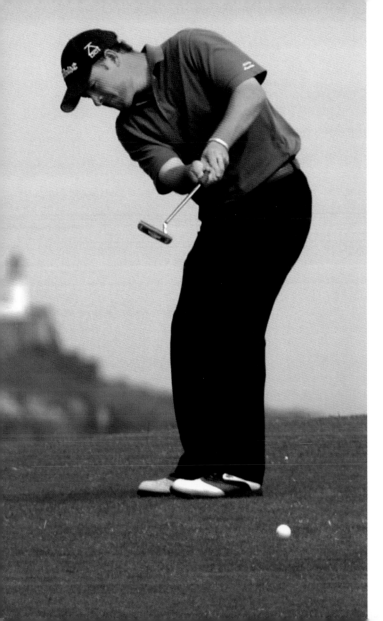

Chapter Two
PLACES

A GOOD WALK...

American writer Mark Twain once remarked that golf was a good walk spoiled. He may have changed his mind if he could have seen some of the spectacular settings and scenery, along with the history, of the courses where the game is played in the British Isles.

Scotland has always been synonymous with the sport, with Bruntsfield Links near Edinburgh staking claim to being the oldest course in the world dating back to the mid-15th century.

But it is St Andrews on the Fife coast that is considered the home of golf and it was from there that the Royal & Ancient Club set the rules worldwide (except in America and Mexico). It is the most used course for the Open Championship, the major tournament in the golfing world.

All the venues for the event are links courses set along the coasts of Britain, although Muirfield in East Lothian is slightly different in that it is upon elevated ancient land claimed from the sea. It has a sandy base and small sea shells are found in the bunkers around the course. It is home to the world's oldest golf club, the 'Honourable Company of Edinburgh Golfers', which was formed in 1744.

One of the most spectacular courses in Scotland is Turnberry, which is set on the Atlantic coast in South Ayrshire right next to the Irish Sea. It has superb views across to the Isles of Mull and Arran and is unusual for a links course because there are no dunes protecting the holes that run close to the sea. It was founded in 1902, but came close to extinction twice as it was requisitioned during both world wars and used as an airbase. During the Second World War, runways were built on some of the holes and it wasn't until 1951 that the course was able to re-open following two years of extensive renovation.

Just along the coast from Turnberry is Royal Troon where the longest and shortest holes in Open Championship golf can be found. The par three eighth hole, known as the 'Postage Stamp', is just 123yd long and

Arnold Palmer drives across the rocks of the Royal Troon, with the Turnberry lighthouse in the background.
4th July, 1977

is regarded as one of the top holes in the world, while the par five sixth ('Turnberry') is just over 600yd. One of the toughest courses in the world is Carnoustie in Angus. Probably one of the remotest courses in the British Isles is Royal Dornoch, located 50 miles north of Inverness. In summer it stays so light there that play has been known to go on until midnight.

NORTH-WEST ENGLAND

Moving back over the border, the second oldest seaside links course in England is Royal Liverpool at Hoylake, which was founded in 1869. It was built on the site of a racecourse and is unusually flat with three sides being bordered by houses, while the Dee Estuary lies on the western side.

Staying in the north-west, situated on the Southport sands is Royal Birkdale. It has hosted the Open eight times, but as yet no player from the United Kingdom has won the tournament there.

ROYAL LYTHAM & ST ANNES

Ten miles away is the most northerly English championship course. Royal Lytham & St Annes is about a mile inland, but Blackpool Tower is clearly visible in the distance. Like Hoylake, it is surrounded by houses, but with the railway line on its western side. It is unique among championship courses in that the first hole is a par three.

KENT COURSES

Heading south and into Kent there are three courses that influenced British golf. Royal St George's in Sandwich is where the first Open championship outside Scotland was played in 1894. It has hosted the Open 13 times, more than any other English course. It is home to the deepest bunker in golf, the 'Himalayas'.

On the same stretch of coastline is the Prince's Golf Club, which along with Royal Portrush in Northern Ireland, is one of only two clubs to have

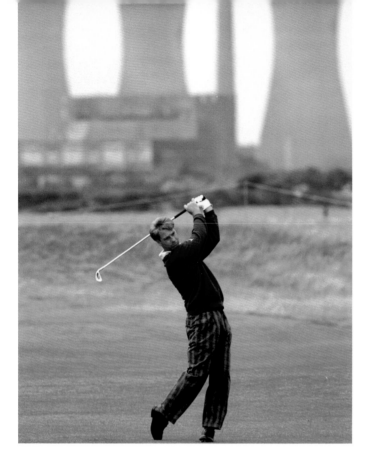

emergency landing by the fourth tee when his Spitfire limped home after being crippled over northern France.

Running along the coast of Sandwich Bay is the Royal Cinque Ports Club near Deal, which hosted two Opens in 1909 and 1920.

COURSES IN WALES

In Wales are two of the more interesting courses, in the county of Powys. Glynneath Golf Club is one, while former Ryder Cup captain and US Masters winner Ian Woosnam learnt the game at Llanymynech, near Oswestry. This has the distinction of being the only course in the world with holes in two countries. Fifteen are in Wales and three over the border in Shropshire, England.

Royal Porthcawl in Glamorgan may not be a place that Tiger Woods will want to remember in

hosted the Open just once. The original layout was completed in 1906 and a year later former Prime Minster A.J. Balfour drove the first ball in the Founder's Vase.

One of the most famous sons of Prince's is Second World War air ace Percy Belgrave 'Laddie' Lucas, who was actually born in the clubhouse. During the war, Lucas was forced to make an

a hurry. As an amateur, he represented the US there in the Walker Cup match of 1995 against Great Britain, but was beaten at the last hole by Gary Wolstenholme. The latter went on to win the Lagonda Trophy played at one of the oldest courses in East Anglia, the wonderfully named Gog Magog Golf Club in Cambridgeshire.

SURREY COURSES

Down in Surrey, the West Course at Wentworth is probably the most televised in Britain, as it is host to three professional tournaments each year: the World Match Play; the PGA Championship; and the Seniors Masters. It also hosted the 1953 Ryder Cup battle between British and US teams, which the latter won by a single point.

As the Second World War began, the Army requisitioned the clubhouse and numerous underground bunkers were built. The fairways were also allowed to grow wild, as the authorities

feared that enemy aircraft might land on them.

Another Surrey course to host

the Ryder Cup is Walton Heath, which staged the 1981 renewal when USA beat Europe. The course was opened in 1904 when its resident professional was James Braid.

SUNNINGDALE

Across the border in Berkshire, Sunningdale has the attraction of a halfway hut, which serves a fine sausage sandwich. Another place where players can get decent refreshments is at the clubhouse at Royal North Devon, the oldest course in England still playing along its original fairways and the first links track to be laid outside Scotland.

Vying with Sunningdale for the title of best inland course in the British Isles is Woodhall Spa in Lincolnshire. It was laid out by Harry Vardon, opened for play in 1905 and is now the home of the English Golf Union.

Ernie Els on his way to winning the World Match Play at Wentworth.
13th October, 2007

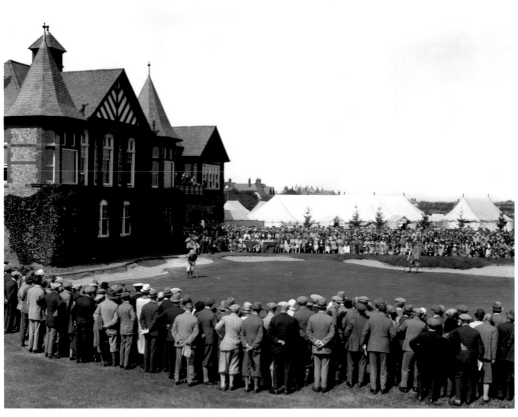

The final putt from Bobby Jones (L) in front of the clubhouse to win the Open Championship at Royal Lytham & St Annes. Jones had been three strokes behind the leader, fellow American Joe Turnesa, but Turnesa stumbled on the back nine, leaving the way clear for Jones, who needed a par to tie or a birdie 4 to win.
26th June, 1926

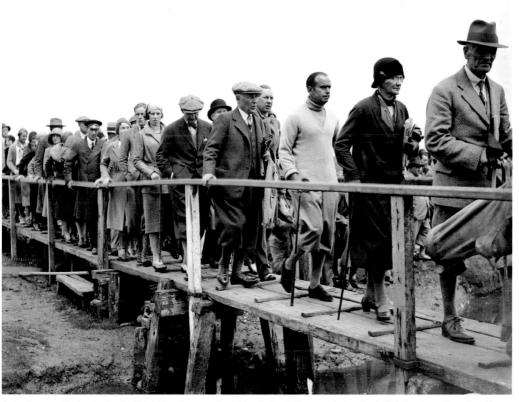

Actor Douglas Fairbanks Senior (third R) walks over the bridge to the 18th green during the British Amateur Championship. Fairbanks was defeated by one hole by J.R. Abercrombie in the first round. A large gallery, including many admiring girls, followed the actor around the course.

19th May, 1931

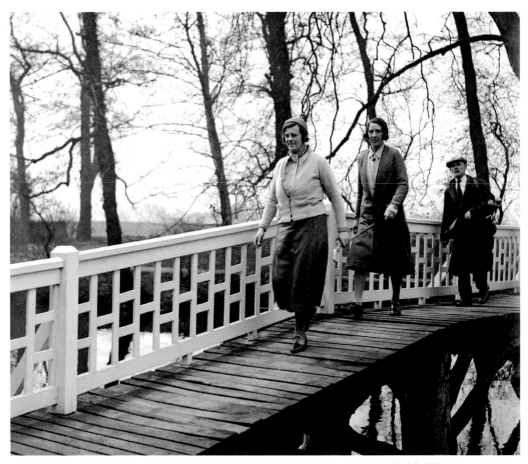

Mrs A.C. Johnston (L) and Miss H. Joannides walk over the bridge during their round in the Ladies' Golf Union International Gold Cup held at Ranelagh Club, Barnes in England.
19th April, 1932

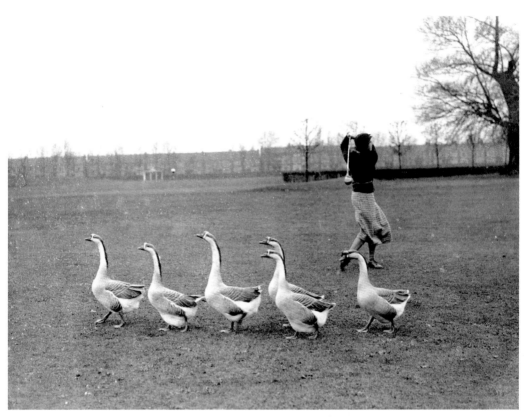

Miss Gwen Cradock-Hartopp plays a stroke to a gallery of geese at Ranelagh Club, Barnes.
10th April, 1935

Two spectators watch from the bank as Francis Ricardo plays out of a bunker by the sixth green at Royal St George's.
26th May, 1937

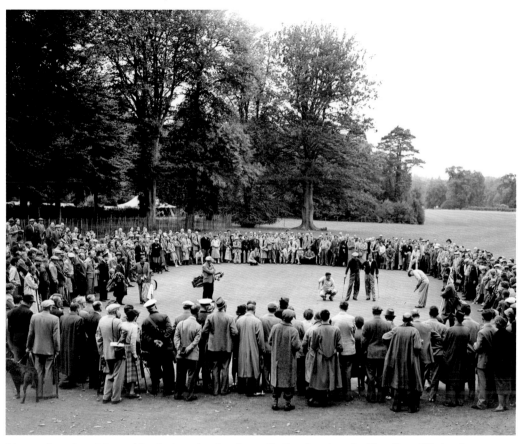

A large gallery of spectators watches the legendary American golfer Sam Snead practise his putting at Wentworth.
30th September, 1953

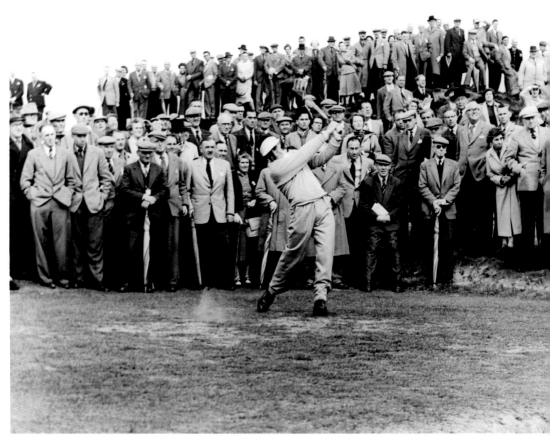

South African Gary Player tees off at the fourth in the 1956 Dunlop Tournament at Sunningdale.
4th May, 1956

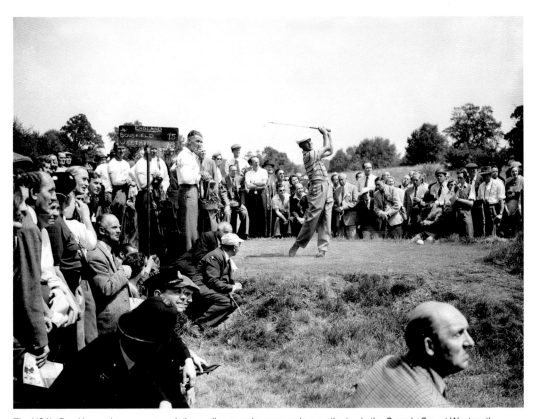

The USA's Ben Hogan draws an appreciative audience as he uses an iron on the tee in the Canada Cup at Wentworth.
21st June, 1956

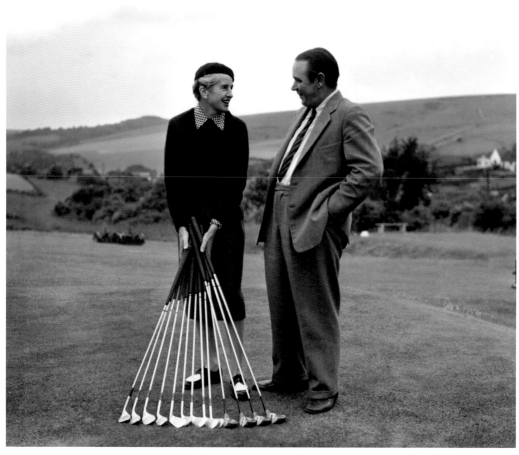

Left-handed golfer Lavinia Martin, of the Pyecombe Golf Club in Sussex, shows fellow member Henry Longhurst a set of specially made golf clubs sent to her from America.

9th August, 1958

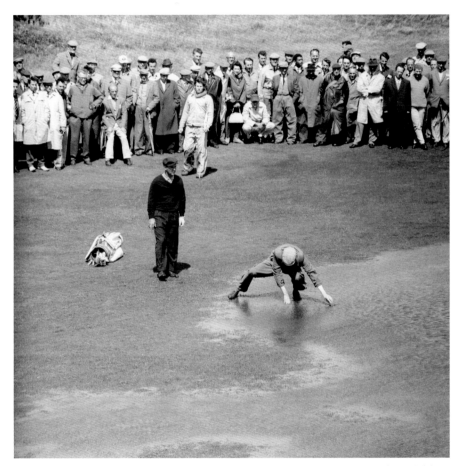

American Arnold Palmer looks on as his caddie fishes for his ball in one of the large pools of water left by overnight rainstorms on the sixth fairway of the Royal Birkdale golf course in Lancashire.
13th July, 1961

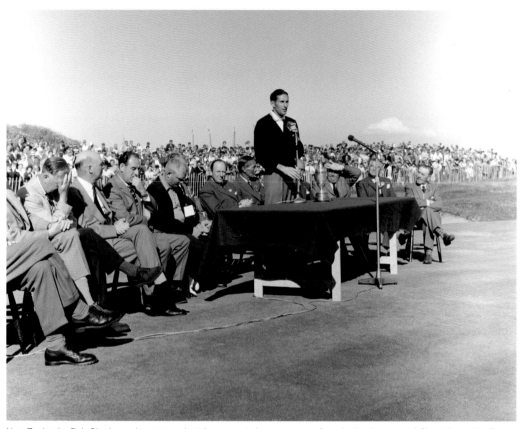

New Zealander Bob Charles makes a speech at the presentation ceremony after winning the coveted Claret Jug at the Open Championship at Royal Lytham & St Annes in Lancashire.
13th July, 1963

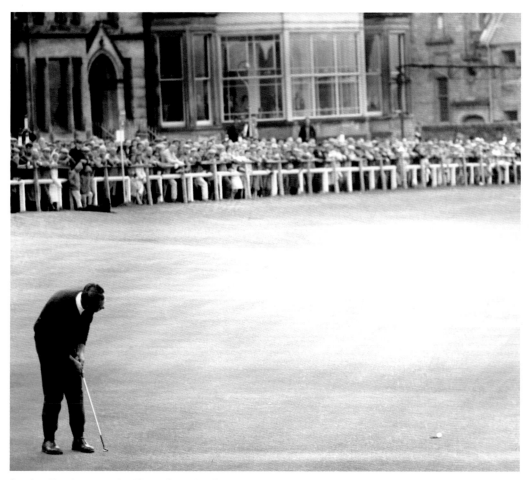

American Tony Lema watches his putt lip the hole for a 68, on the second day of the British Open at St Andrews.
9th July 1964

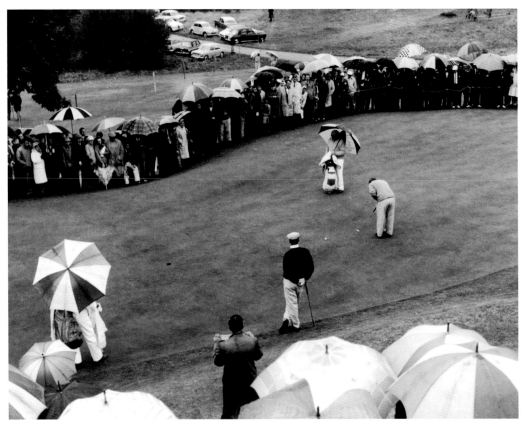

Neil Coles putting on the third green in the Piccadilly World Match Play Championship at Wentworth.

9th October, 1964

Facing page: Arnold Palmer (L) looks on as Gary Player (R) putts on the 16th green at Wentworth.

10th October, 1964

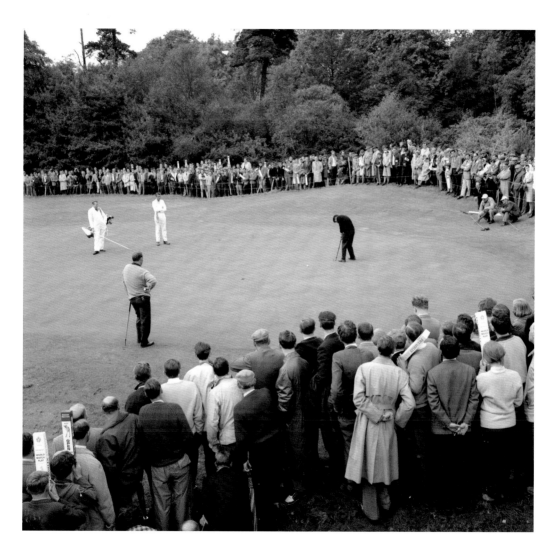

Jack Nicklaus chips out of heavy rough during the Piccadilly World Match Play Championship at Wentworth.
8th October, 1966

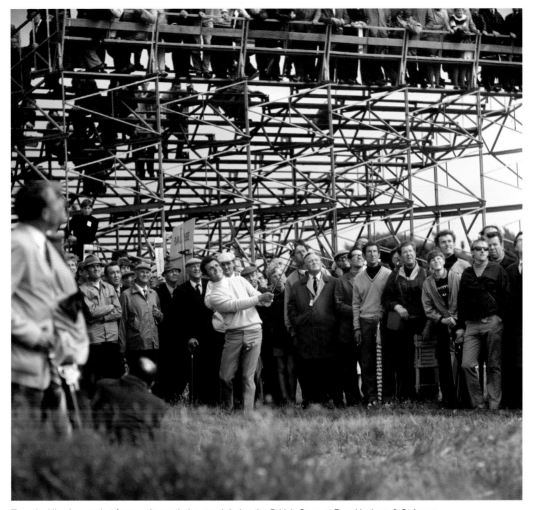

Tony Jacklin plays a shot from underneath the stand during the British Open at Royal Lytham & St Annes.
12th July, 1969

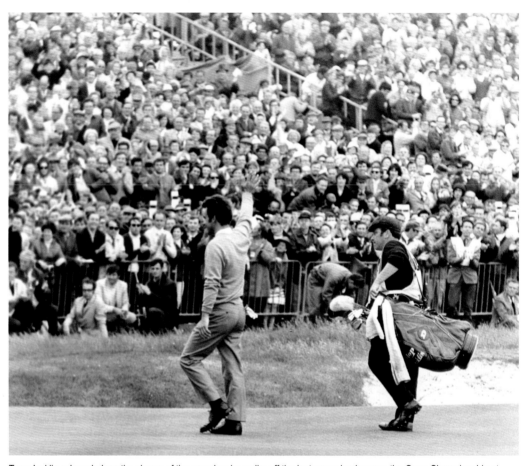

Tony Jacklin acknowledges the cheers of the crowd as he walks off the last green having won the Open Championship at Royal Lytham & St Annes. It was the first time in 18 years that a British golfer had won the British Open.
12th July, 1969

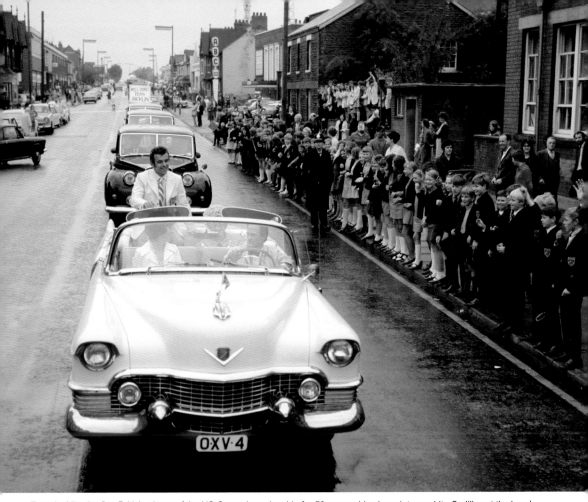

Tony Jacklin, the first British winner of the US Open championship for 50 years, rides in a vintage white Cadillac at the head of a motorcade through his home town of Scunthorpe, in Lincolnshire.
24th June, 1970

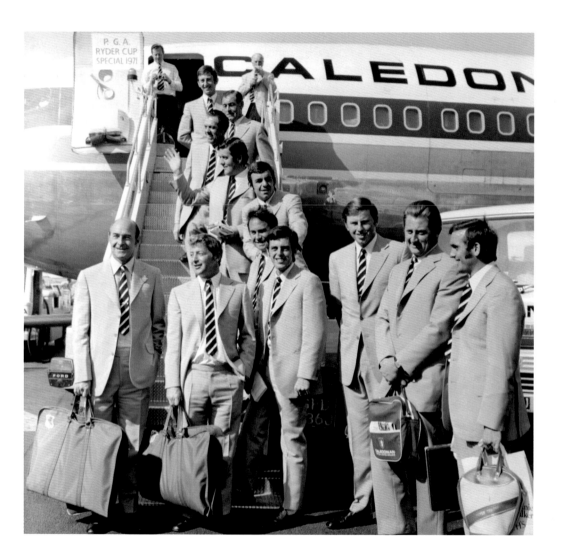

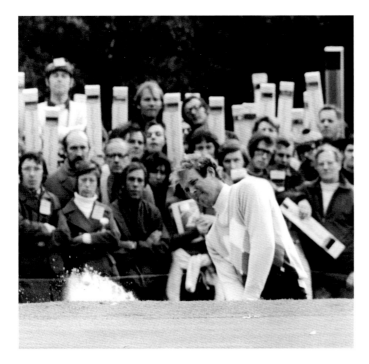

Tom Weiskopf plays out of a bunker during the 1972 Piccadilly World Match Play Championship at Wentworth.
14th October, 1972

Facing page: The Great Britain and Ireland team about to board the plane which will take them to St Louis, USA for the Ryder Cup: (on steps, top–bottom) John Garner, Christy O'Connor, Peter Butler, Harry Bannerman, Tony Jacklin, Brian Huggett; (front, L–R) captain Eric Brown, Maurice Bembridge, Bernard Gallacher, Peter Oosterhuis, Brian Barnes, Peter Townsend.
9th September, 1971

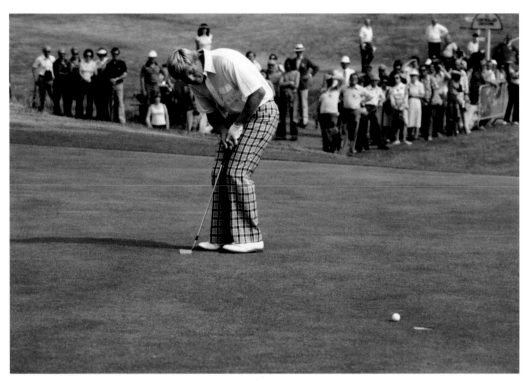

Jack Nicklaus makes a putt during his famous battle with fellow American Tom Watson at Turnberry's first, dramatic British Open Championship in 1977. Tom Watson won by one shot on the final hole.

7th July, 1977

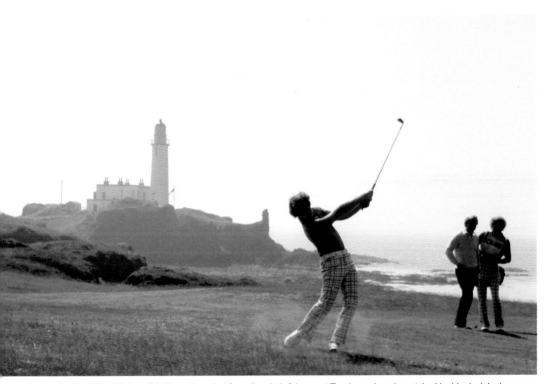

Eventual winner Tom Watson (L) hits an iron shot from the ninth fairway at Turnberry, keenly watched by his rival Jack Nicklaus (second R) and caddy, against the dramatic backdrop of the coast.
11th July, 1977

Driving from the elevated fifth tee at Cottesmore Golf Club, Pease Pottage in West Sussex.
1st February, 1980

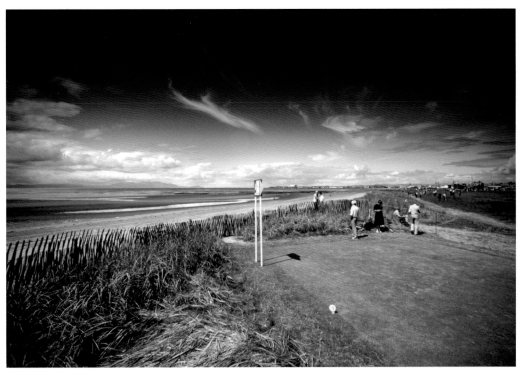

Royal Troon in the sunshine. Founded in 1878, the Royal Troon golf course was extended from its original six holes to eighteen by 1888, and has been reshaped and added to since then. The course held its first Open Championship in 1923.
1982

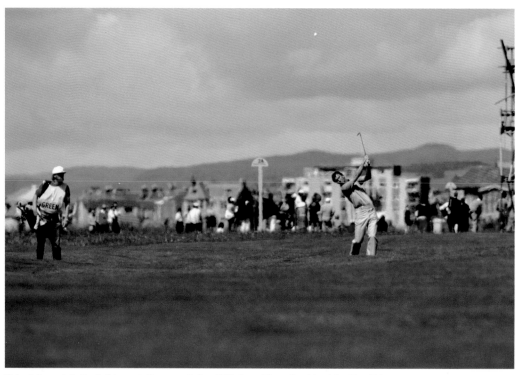

Hubert Green lofts the ball towards the green in the 1982 Open Championship at the Royal Troon.
17th July, 1982

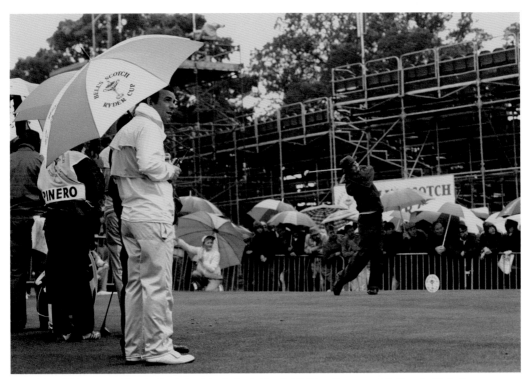

USA's Mark O'Meara tees off on the first hole at the Belfry, Sutton Coldfield, as Europe captain Tony Jacklin looks on.
14th September, 1985

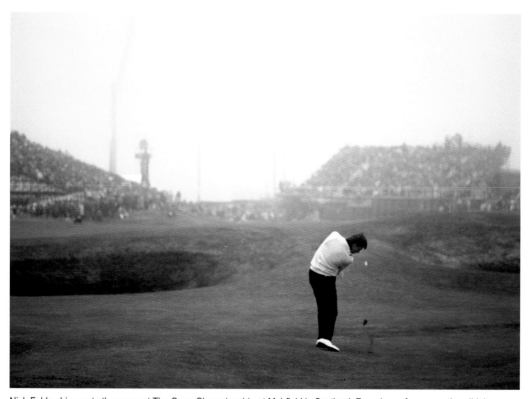

Nick Faldo chips on to the green at The Open Championship at Muirfield in Scotland. Four days of poor weather didn't dampen Faldo's resolve and he won his first major championship tournament.
18th July, 1987

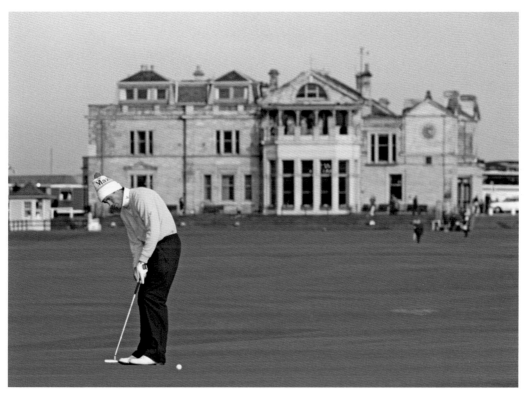

Australia's Ian Baker-Finch in front of the Royal and Ancient clubhouse at St Andrews while playing in the Alfred Dunhill Cup.
16th October, 1992

Nick Faldo tests the facilities on his way to winning the Open Championship at Sandwich in Kent.
18th July, 1993

Facing page: Barry Lane and Peter Baker on the tenth green at the Belfry during the Ryder Cup.
24th September, 1993

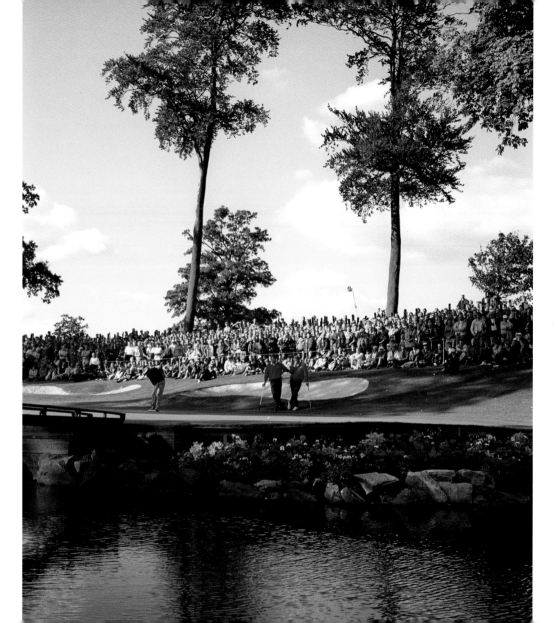

Europe's Colin Montgomerie (L) and Nick Faldo line up a putt on the tenth green during the 30th Ryder Cup at the Belfry.
25th September, 1993

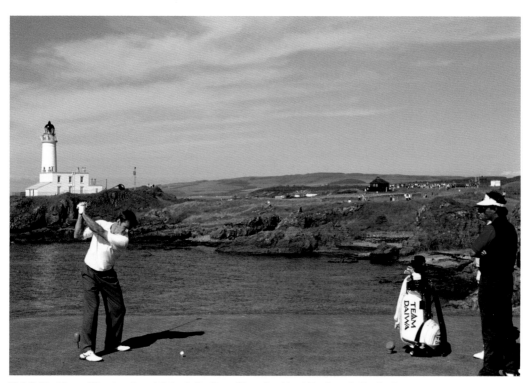

Nick Faldo drives off the daunting ninth tee in the Open Championship at Turnberry in Scotland.
13th July, 1994

It takes dedication to perfect your game and amateur golfers are no less dedicated than professionals. Here club members stride along a frosty fairway on a cold and bright morning in the winter.

10th November, 1996

Australian Greg Norman putts on the seventh green of the beautiful Loch Lomond Golf Club, with landscape of the Trossachs rising in the distance, during the 1997 Loch Lomond World Invitational.
11th July, 1997

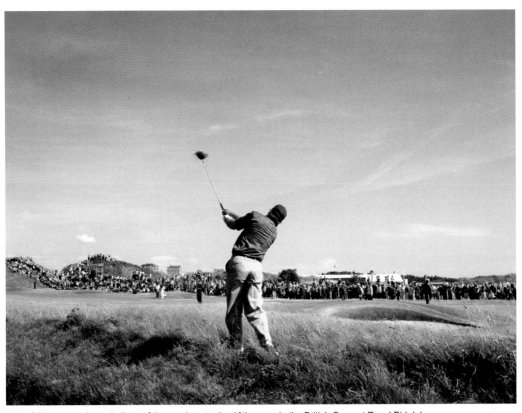

Mark O'Meara punches a ball out of the rough on to the 13th green in the British Open at Royal Birkdale.
16th July, 1998

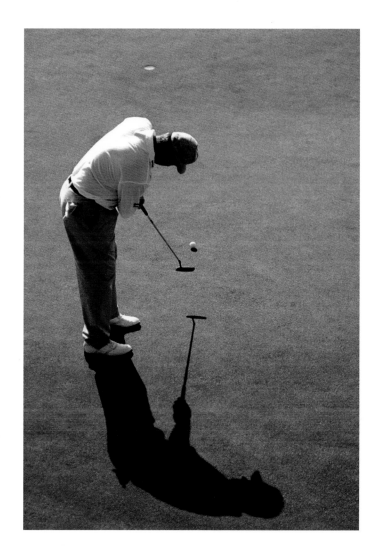

Lee Westwood on the 12th green at
Slaley Hall, in Northumberland while
competing in the Compaq European
Grand Prix Tour.
24th June, 1999

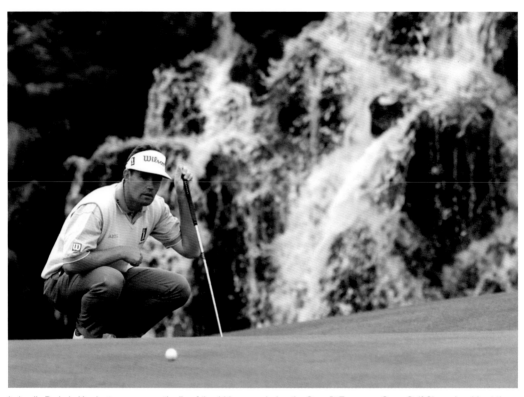

Ireland's Padraig Harrington assesses the lie of the 14th green during the Smurfit European Open Golf Championship at the K Club, in County Kildare, Republic of Ireland.

6th July, 2001

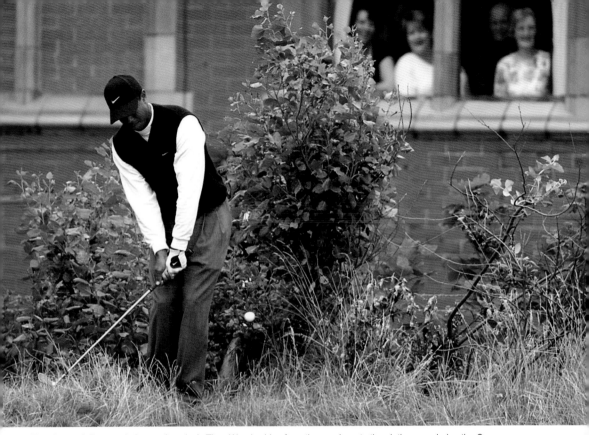

People watch from a window as America's Tiger Woods chips from the rough on to the ninth green during the Open Championship at Royal Lytham & St Annes.
21st July, 2001

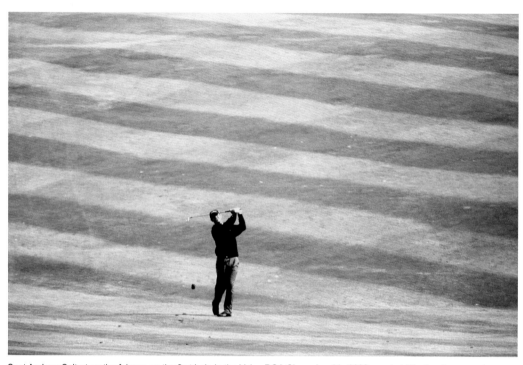

Scot Andrew Coltart on the fairway on the first hole in the Volvo PGA Championship 2002 event at Wentworth.
23rd May, 2002

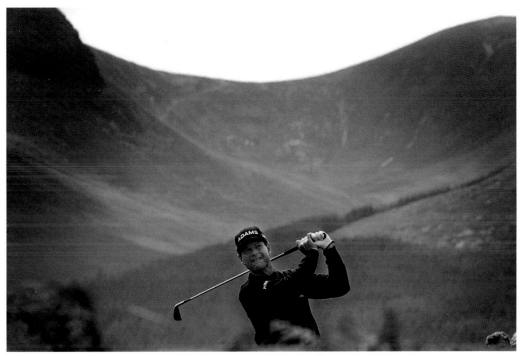

Tom Watson tees off at the sixth with the Mountains of Mourne in the background on day two of the Senior British Open at the Royal County Down golf course in Newcastle, Northern Ireland.
26th July, 2002

Karrie Webb, Australia's most successful female golfer, walks on to the 18th green past the scoreboard during the final day of the Women's British Open at Turnberry, which she won by two shots.

11th August, 2002

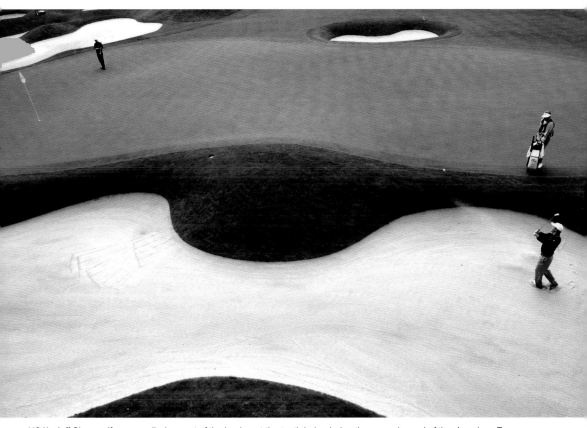

USA's Jeff Sluman (foreground) plays out of the bunker at the tenth hole, during the second round of the American Express Championship, at Mount Juliet Golf Course, County Kilkenny, Republic of Ireland.
20th September, 2002

Paul McGinley celebrates Europe winning the 34th Ryder Cup by taking a dip in the lake by the 18th hole at the Belfry.
29th September, 2002

Crowds gather to watch the third round of the Barclays Scottish Open at Loch Lomond.
12th July, 2003

A greenkeeper prepares the sixth hole for practice day at the Barclays Scottish Open at Loch Lomond.
7th July, 2004

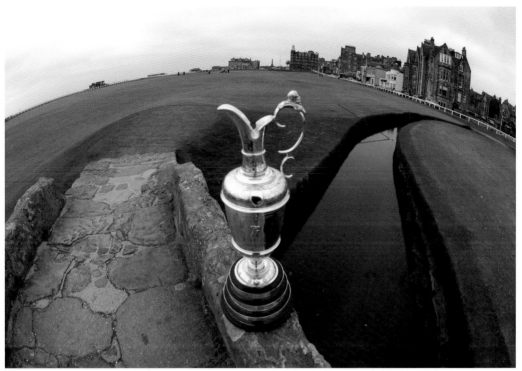

The Claret Jug, awarded to the winner of the Open Championship, rests on the bridge on the 18th fairway at St Andrews. **26th April, 2005**

Colin Montgomerie on the tenth tee during the second round of the Johnnie Walker Championship at Gleneagles, Perthshire.
23rd June, 2006

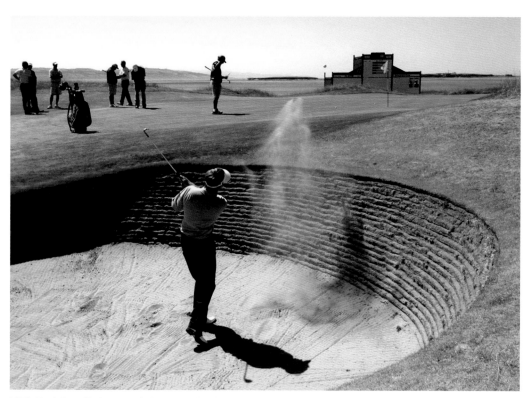

USA's Davis Love III plays out of a bunker at the 13th green during a practice session at Royal Liverpool Golf Club, Hoylake.
17th July, 2006

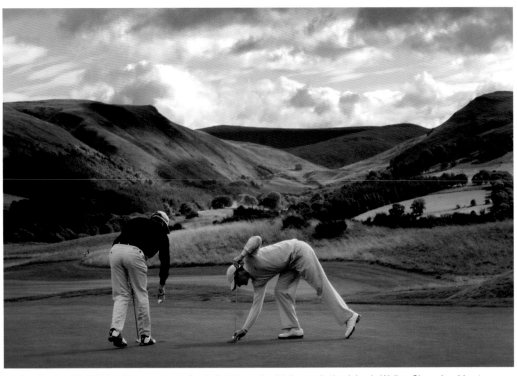

Bradley Dredge (L) and Marc Warren prepare for their putts on the third green in the Johnnie Walker Championship at Gleneagles in Scotland.
31st August, 2007

South Africa's Ernie Els walks to
the eighth green at Wentworth during
the HSBC World Match Play
Championship at Wentworth.
13th October, 2007

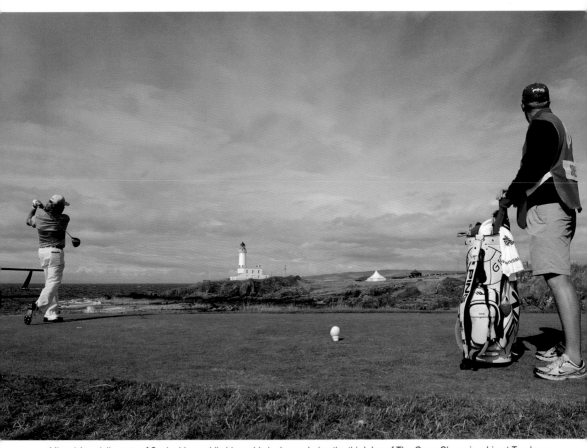

Miguel Angel Jimenez of Spain drives while his caddy looks on during the third day of The Open Championship at Turnberry.
18th July, 2009

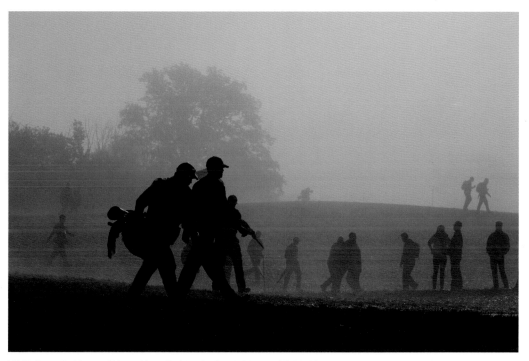

USA's Steve Stricker and his caddy walk down the fourth fairway of Celtic Manor as the early morning mist hangs on during the fourth day of the 38th Ryder Cup. Rain and mud had bedevelled play throughout the weekend, delaying the final day's play until the Monday for the first time in the Cup's history. Europe would go on to win by just one point.
4th October, 2010

Chapter Three

MOMENTS

TRIUMPHS & DEFEATS

Anyone who has played golf knows what a frustrating game it can be; one minute you play the perfect shot, the next you are up to your knees in a ditch trying to find your ball.

There is a thin line separating triumph and defeat, something one of the great players of the early 20th century, Harry Vardon, found out at the 1902 Open at Hoylake. He needed only two fours over the last two holes to tie with Alex 'Sandy' Herd. His penultimate putt on the 18th green looked to be going in, but at the last moment stopped right on the edge of the hole. A puff of wind would have blown it in, but when one needs the wind the air is always still...

That was Herd's first and only win in the Open, and two years later Jack White also upstaged the 'Great Triumvirate' of James Braid, J.H. Taylor and Harry Vardon when winning at Sandwich. On the way to victory he became the first player to break the 300 barrier in the tournament with a four-round total of 296.

Possibly the most remarkable Open victory of the early years of the century was that achieved by Scotland's George Duncan in 1920, the first championship after the Great War. He was 13 shots adrift of the leader Abe Mitchell after two rounds, but by the end of the third he had made up the deficit.

The dramatic turnaround was attributed to the purchase of a new driver by Duncan after his two rounds of 80. That was not the only amazing comeback achieved during his career, as seven years later, when playing

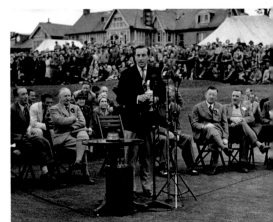

in the Irish Open at Portmarnock, he was 14 shots adrift of the leader in the last round, but still managed to win.

The greatest force in women's golf at the time was Joyce Wethered who won the British Ladies' Amateur Golf Championship four times during the decade, and was English Ladies' champion for five consecutive years.

Although the 1930s heralded the arrival of Henry Cotton who won the first of his three British Opens in 1934, it was also the decade when there were a remarkable four golfers who would each win the Championship just once in their careers: Alf Perry (1935), Alf Padgham (1936), Reg Whitcombe (1938) and Richard Burton (1939).

The Walker Cup, the competition for amateur golfers representing Great Britain and Ireland against the United States, was won for the first time by the Great Britain team in 1938.

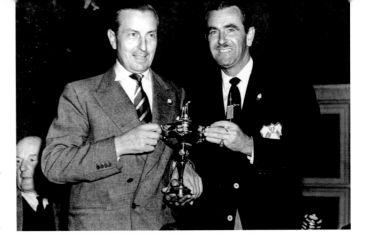

Above: The two captains, Great Britain's Henry Cotton (L) and USA's Lloyd Mangrum, with the Ryder Cup. 29th September, 1953

Facing page: Open champion Henry Cotton makes his acceptance speech after collecting the Claret Jug. 2nd July, 1948

THE RYDER CUP

A similar contest for the professionals, the Ryder Cup, was begun in 1927, and in the early years it resulted in some very exciting battles. Particularly in 1929 when 10,000 fans flocked to Moortown Golf Club in Leeds to see the famous Americans in action. Captain of the British side was George Duncan, who had to face the great Walter Hagen in a singles match. Apparently he was spurred on to victory after overhearing Gene Sarazen tell Hagen that he thought he was guaranteed a point against the Brit. That motivated Duncan, who led his team to a seven points to five victory. There was also a dramatic finish to the 1933 Cup when the two sides met at Southport. Although the home side were without the inspirational Henry Cotton, they were a tough proposition in their

own backyard. However, it all came down to the final match between American Herman Densmore Shute and Sid Easterbrook. Shute had a putt to win the match, but missed two in succession to give Easterbrook a putt to win, which he duly sunk from three feet to reclaim the Cup that the US had won two years earlier.

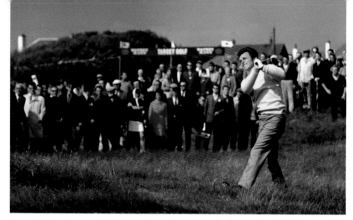

Tony Jacklin plays out of the rough on his way to winning the British Open at Royal Lytham & St Annes in 1969.
12th July, 1969

POST-WAR YEARS

After the Second World War, the US were to dominate the competition, and although it was a close-run thing in 1953, that year's battle at Wentworth in Surrey ended up a disastrous one for the Brits.

Making his debut in the contest, Peter Alliss had a crucial match against Jim Turnesa in the singles. He was losing by just one hole, but was in a good position as they approached the 18th hole. However, he took four shots from the fringe of the green and lost his match.

Bernard Hunt could have saved the day with a putt from four feet that would have drawn the contest, but the pressure proved too much: he missed and the US kept their hold on the trophy. Revenge came four years later at Lindrick in Yorkshire when Britain was led by Welshman Dai Rees. The home side rallied to win five of the seven singles matches.

Henry Cotton's final win in the Open came in 1948. When Max Faulkner won the contest three years later, it was said that such was his confidence in victory, when he was two or three shots ahead he was signing the books of autograph hunters: '*Open champion 1951*'.

TONY JACKLIN

Arguably the greatest golfing achievement of the 20th century was that of Scunthorpe-born Tony Jacklin. Not only did he become the first British winner of the Open for 18 years (in 1969) following Faulkner, he went on to land the US version a year later in 1970 by seven strokes, the first Briton to do so since 1920.

PETER OOSTERHUIS

After a brilliant amateur career Peter Oosterhuis looked the man to follow in the footsteps of Jacklin when he won the European Order of Merit title four years in a row from 1971 to 1974, and he went close on two occasions when finishing runner-up in both 1974 and 1982. The tall Londoner also suffered agonising defeats in the Open and the US Masters after leading in both.

THE 1980S ONWARDS

Paul Way won the 1985 British PGA Championship and two years later the European Open. Way was part of the victorious Europe team of 1985, although it all came down to Scotsman Sam Torrance. He faced US Open champion Andy North and soon fell behind. However, he fought back and it was neck-and-neck going to the 18th. North hit his ball into water, which left Torrance to hole out an 18-footer to win the match and the Ryder Cup, which he did comfortably. Torrance also captained the European team to victory in the Ryder cup in 2002.

BRITISH MASTERY

Between 1988 and 1991 inclusive, an Englishman (Nick Faldo twice), a Scotsman (Sandy Lyle) and a Welshman (Ian Woosnam) all won the US Masters in Georgia, Atlanta, one of the four leading major titles in the game of golf.

Faldo won that tournament again in 1996 when he got the better of an enthralling battle with the Australian Greg Norman. Woosnam went on to captain the successful 2006 European team in the Ryder Cup.

WINNING RUN

One of the most extraordinary winning runs of the late 1990s was that of Lee Westwood. Over a twelve-month period starting in November 1997, he won an impressive eight tournaments worldwide, including first-time wins in America and Britain.

Unsurprisingly, perhaps, he also won the Australian Open in Melbourne after beating the home favourite Greg Norman in a play-off.

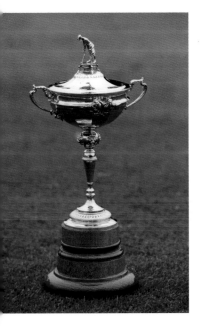

The gold Ryder Cup trophy first presented in 1927.
23rd September, 1993

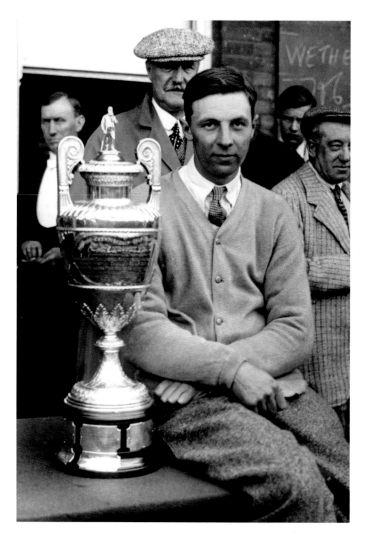

British Amateur Champion Roger Wethered relaxes with the trophy after the presentation.
12th May, 1923

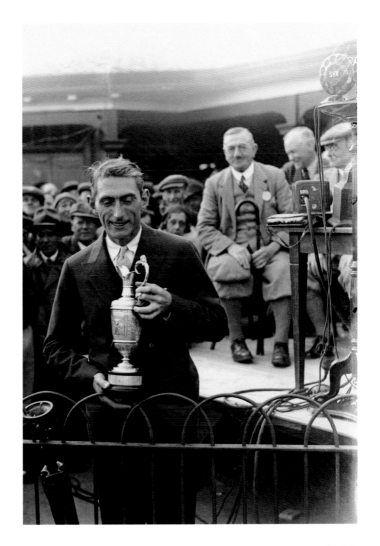

British Open Champion Tommy
Armour poses with the Claret
Jug for the press.
6th June, 1931

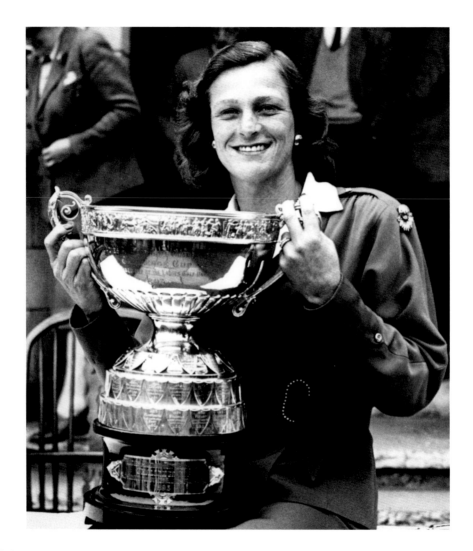

South African Bobby Locke won the 1949 British Open at Royal St George's in Sandwich.
9th July, 1949

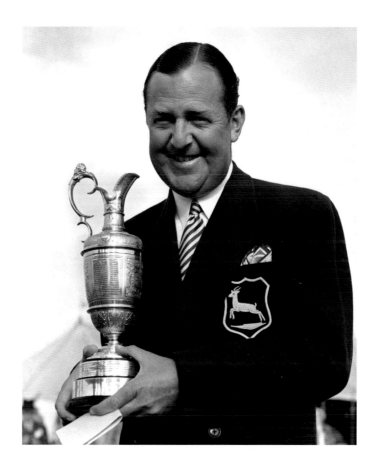

Facing page: Leading American golfer Mildred 'Babe' Zaharias after winning the British Ladies' Amateur Open Championship.
12th June, 1947

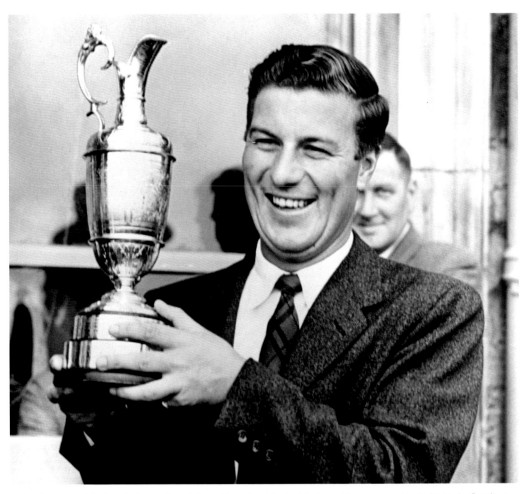

Peter Thomson celebrates winning the British Open Championship at St Andrews. Thomson would win the trophy five times.
6th July, 1955

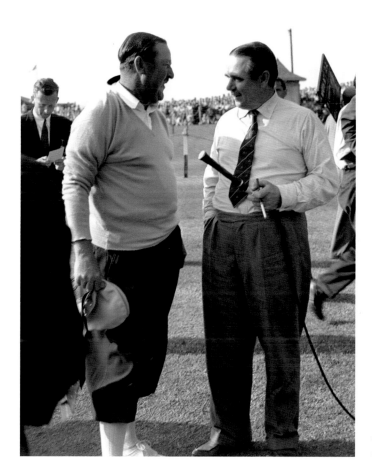

Bobby Locke (L) is interviewed after
winning the 1957 British Open.
5th July, 1957

Great Britain captain Dai Rees (L) congratulates his foursomes partner Ken Bousfield after the latter sank the winning putt to earn Britain's only foursomes point in the 1957 Ryder Cup.

4th October, 1957

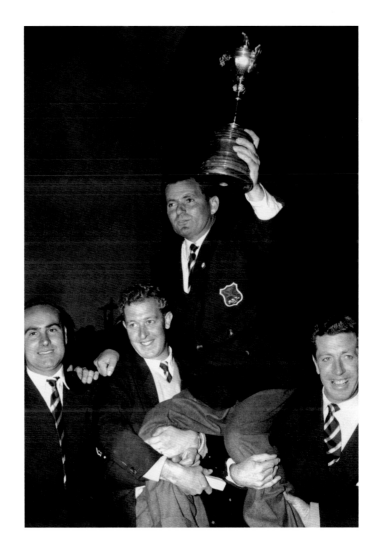

Members of the victorious British
Ryder Cup team carry their captain
Dai Rees and the trophy aloft.
5th October, 1957

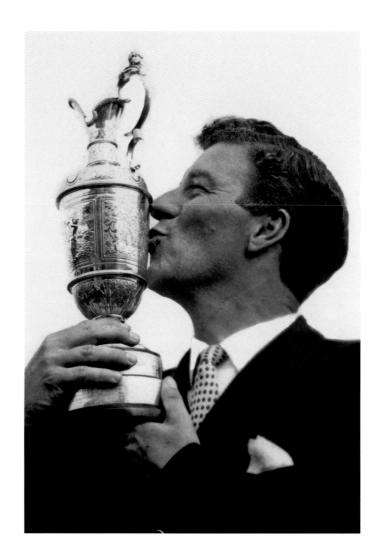

The start of a tradition? Peter
Thomson kisses the trophy after
winning the Open Championship at
Royal Lytham & St Annes.
1958

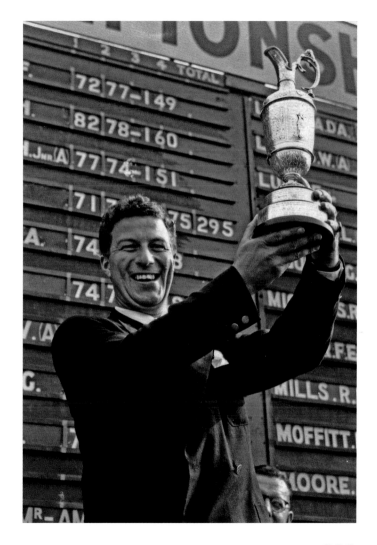

Peter Thomson, British Open Champion for the fourth time, celebrates his win in front of the leaderboard.
1958

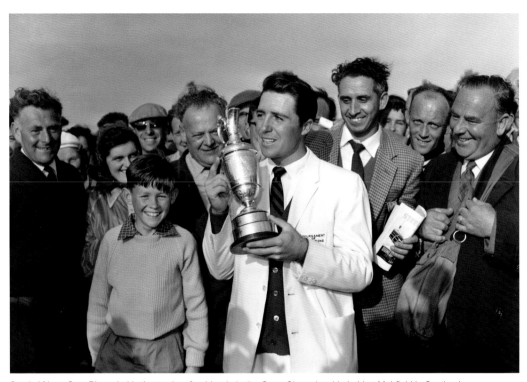

South African Gary Player holds the trophy after his win in the Open Championship held at Muirfield in Scotland.
3rd July, 1959

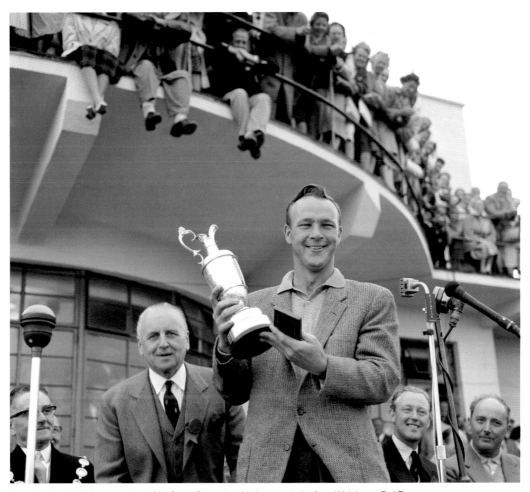

American Arnold Palmer won the 1961 Open Championship by one stroke from Welshman Dai Rees.
15th July, 1961

PROFESSIONAL GOLFERS ASSOCIATION
SCORE BOARD

DUNLOP-MASTERS

NAME	1	2	3	4	TOTAL
HITCHCOCK. J.	73	68	75	70	286
HUGGETT. B.G.C.	69	74	71	69	283
HUNT. B.J.	67	73	78		
KING. S.L.	77	72	76	70	
LEES. A.	72	73	74	66	
LOCKE. A.D.A.	71	71			
MIGUEL. A.G.	71	75			
MILLER. D.	70	7			
MOFFITT. R.L.	71	73			
NAGLE. D.G.	71	69			

NAME	1	2	3	4	TOTAL
O'CONNOR. C.	73	70	69	72	284
PANTON. J.	71	69	69	73	282
PHILLIPS. F.	73	71	68	78	290
POVALL. M. J.	75	70	77	83	305
REES. D. J.	71	66	70	71	278
SCOTT. S. S.	71	75	76	74	296
THOMAS. D.C.	75	67	74	72	288
SON. P.W.	71	67	70	72	280
NIDA. N.G.	71	75	71	72	289
ADE. C.H.	79	75	78	80	312
AN. H.					66

NAME					
WHITEHEAD. E.RA	7				
WILKES. B.					

LEAD

New Zealander Bob Charles after
winning the Open Championship at
Royal Lytham & St Annes.
13th July, 1963

Facing page: Dai Rees gives his acceptance speech after
winning the Dunlop Masters at Wentworth.
12th August, 1962

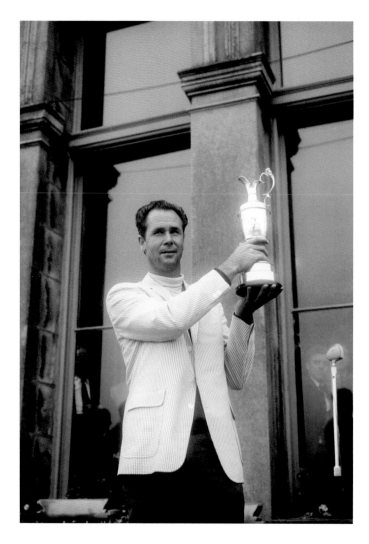

American Tony Lema holds the trophy
after winning the 1964 British Open.
10th July, 1964

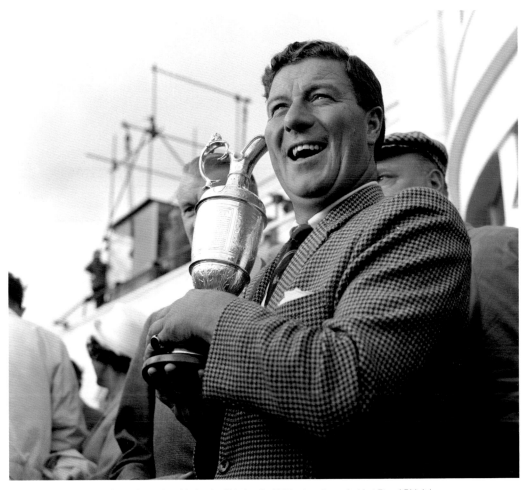

Peter Thomson won the Open Championship for the fifth time in 1965, when it was held at Royal Birkdale.
9th July, 1965

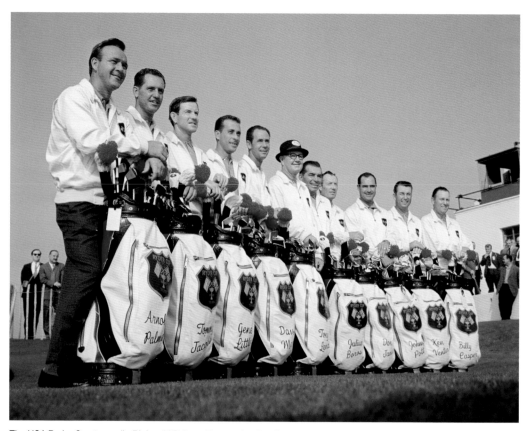

The USA Ryder Cup team: (L–R) Arnold Palmer, Tommy Jacobs, Gene Littler, Dave Marr, Tony Lema, captain Byron Nelson, Julius Boros, Don January, Johnny Pott, Ken Venturi, Billy Casper.
8th October, 1965

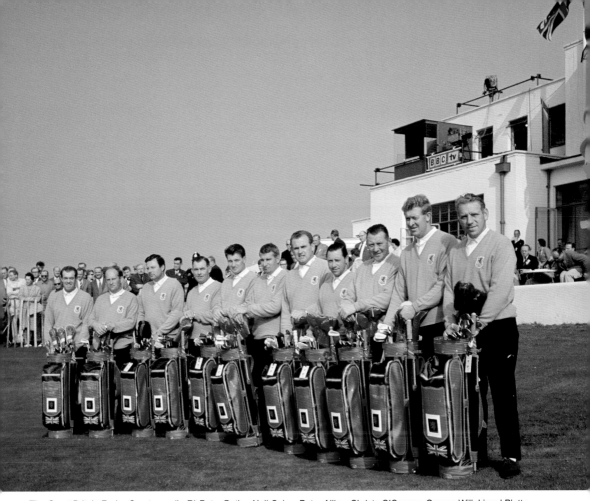

The Great Britain Ryder Cup team: (L–R) Peter Butler, Neil Coles, Peter Alliss, Christy O'Connor, George Will, Lionel Platts, Dave Thomas, Jimmy Hitchcock, Jimmy Martin, Bernard Hunt, captain Harry Weetman.
8th October, 1965

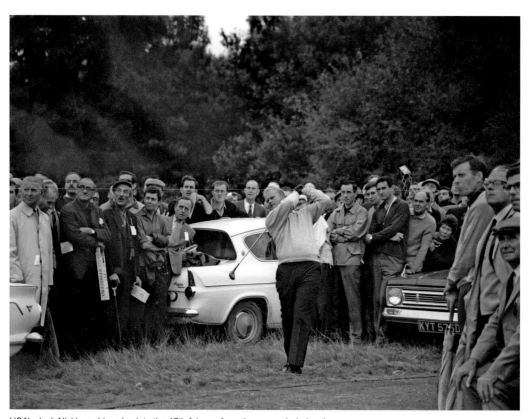

USA's Jack Nicklaus drives back to the 17th fairway from the car park during the Piccadilly World Match Play Championship at Wentworth.
6th October, 1966

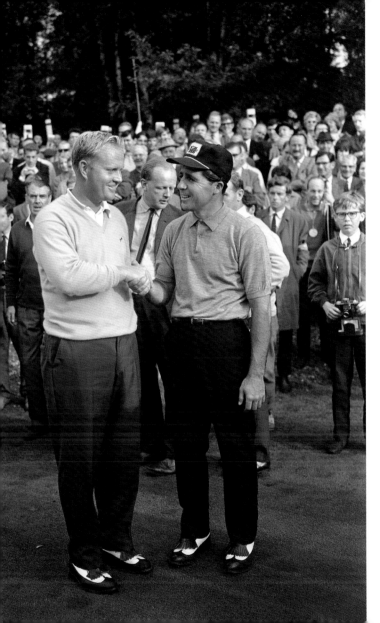

Jack Nicklaus (L) shakes hands with the winner of the World Match Play Championship, Gary Player.
8th October, 1966

Britain in Pictures

American Doug Sanders presents his girlfriend Scotty with a rose at Hoylake during The Open Championship.
15th July, 1967

Facing page: An elated Roberto de Vicenzo holds the trophy aloft after winning the Open at the Royal Liverpool course at Hoylake.
16th July, 1967

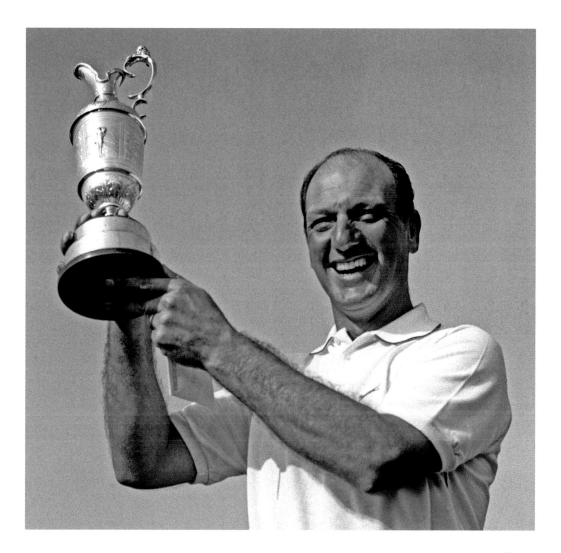

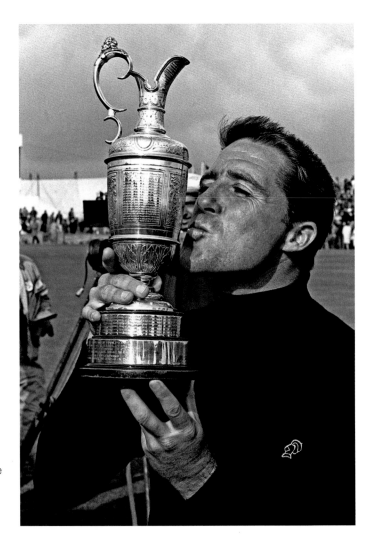

Gary Player continues the tradition of kissing the Claret Jug after winning the Open Championship at Carnoustie, repeating his triumph in the 1959 competition.

13th July, 1968

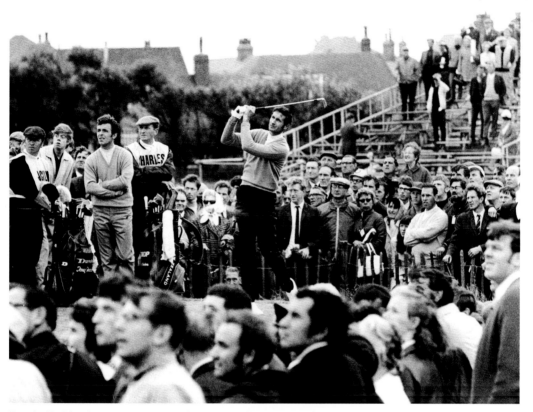

Tony Jacklin (L) and spectators watch Bob Charles drive off the tee in the Open Championship at Royal Lytham & St Annes.
12th July, 1969

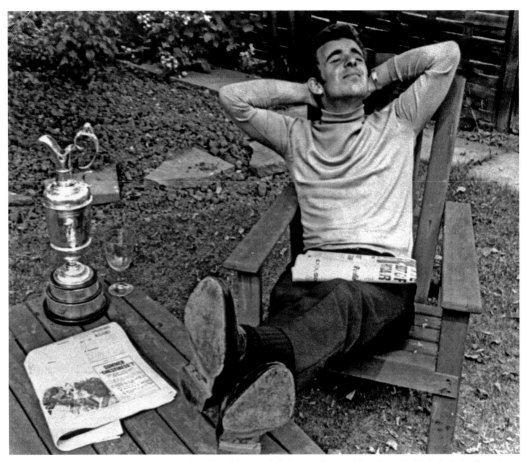

The day after winning the Open Championship at Royal Lytham & St Annes, Tony Jacklin relaxes in his father's back garden, near Scunthorpe in Lincolnshire.
13th July, 1969

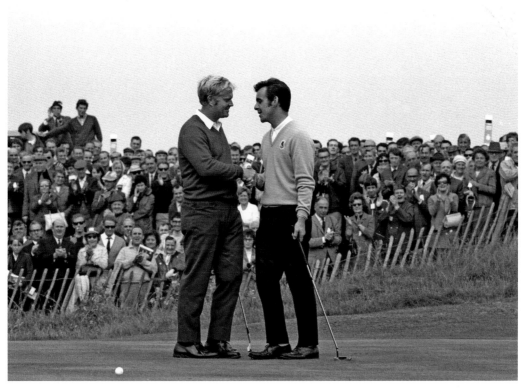

USA's Jack Nicklaus (L) congratulates Tony Jacklin after the British player beat him in their singles match. The two teams would finish level on points, however, meaning the USA retained the 18th Ryder Cup.
20th September, 1969

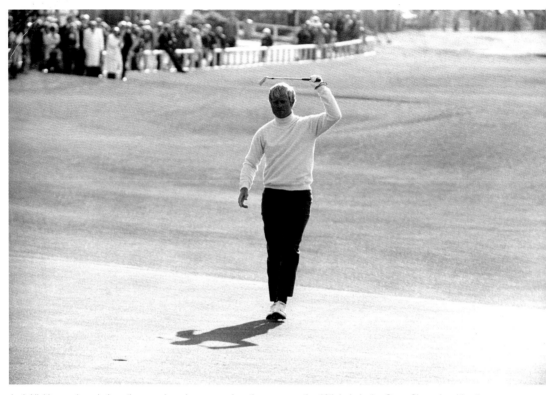

Jack Nicklaus acknowledges the crowds as he approaches the green on the 18th hole in the Open Championship at St Andrews. It was his second British Open win and it ended a three-year major title drought for the American.
11th July, 1970

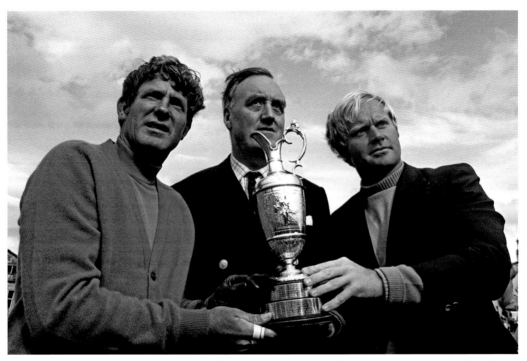

Doug Saunders (L) and Jack Nicklaus (R) hold the Claret Jug, which they shared for a few hours. Between them is Cabinet Minister Willie Whitelaw, who was Captain of the Royal & Ancient Golf Club at the time.
11th July, 1970

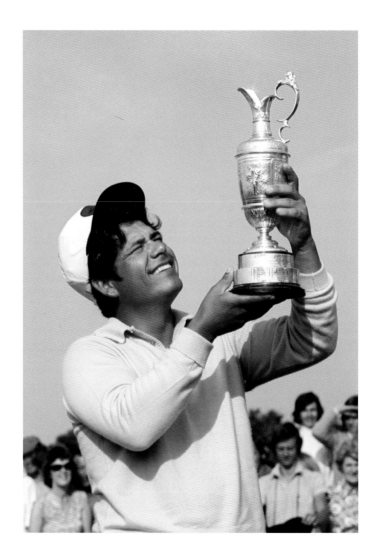

American Lee Trevino after winning
the Open Championship at Muirfield.
Trevino had come close to winning in
1970, before finishing joint second.
15th July, 1972

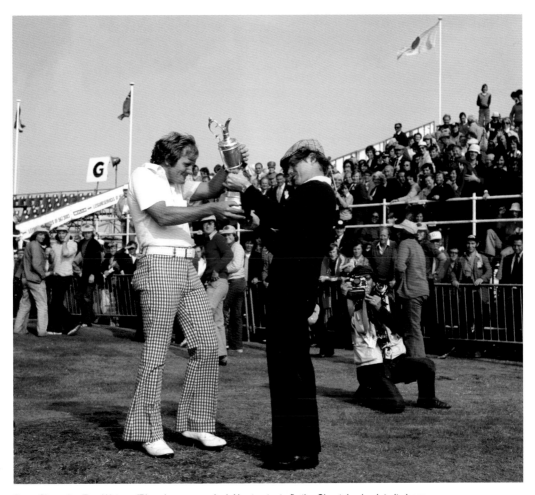

Open Champion Tom Watson (R) and runner-up Jack Newton try to fix the Claret Jug back to its base.
17th July, 1975

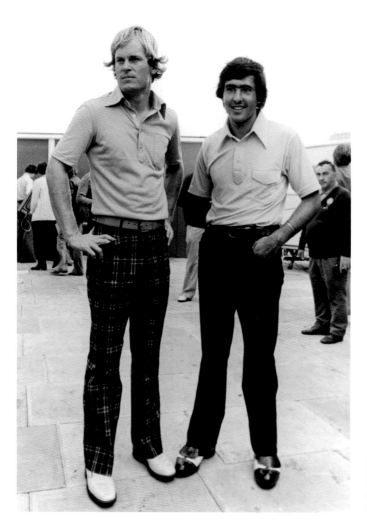

Open Champion Johnny Miller (L) with the runner-up, 19-year-old Seve Ballesteros, who still seems pleased with finishing second.
9th July, 1976

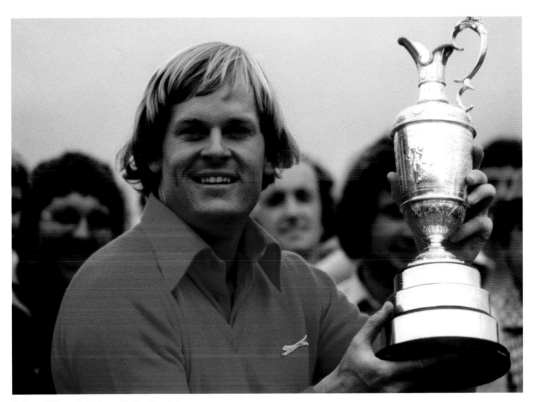

Johnny Miller celebrates with the Claret Jug.
10th July, 1976

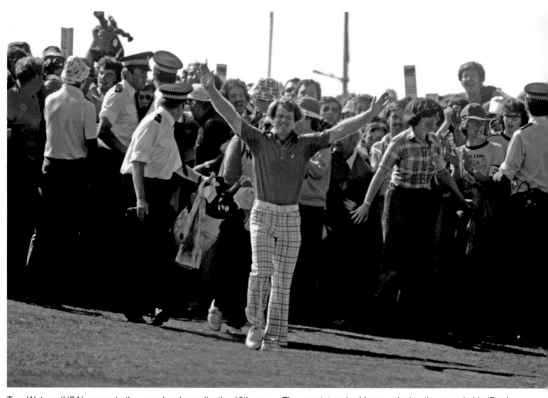

Tom Watson (USA) waves to the crowd as he walks the 18th green. The spectators had been enjoying the remarkable 'Duel in the Sun' between Watson and Jack Nicklaus that day, a battle in which Watson ultimately prevailed with the final putt.
7th July, 1977

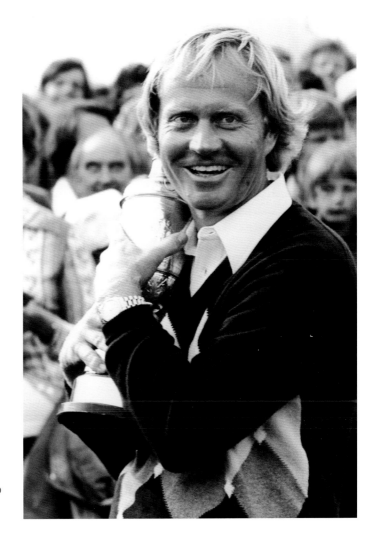

Open Champion Jack Nicklaus hugs
the Claret Jug close after losing out to
Tom Watson the year before.
15th July, 1978

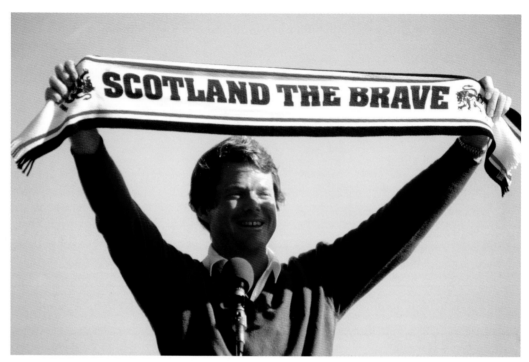

Open Champion Tom Watson holds up a 'Scotland The Brave' scarf during his victory speech. Watson's remarkable record in the British Open, and winning all but one of his five Opens on Scottish courses, practically made him an honorary Scotsman.
20th July, 1982

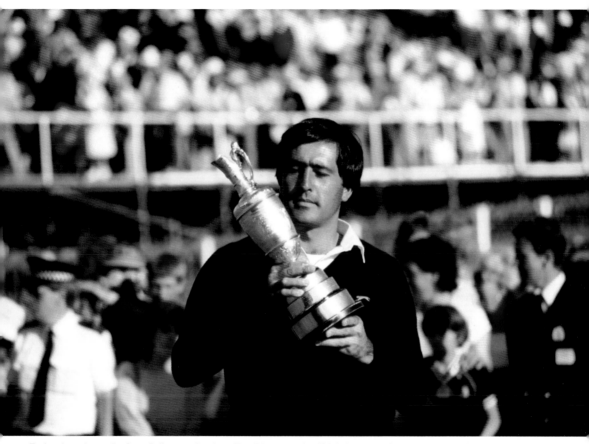

To the victor the spoils. Seve Ballesteros just beat Tom Watson on the 18th hole with 15-foot birdie putt, his famous fist-pumping celebration being remembered as much as, if not more than, his golf on the day.
22nd July, 1984

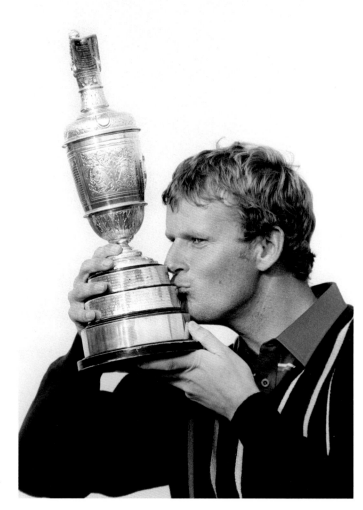

Sandy Lyle kisses the Open
Championship trophy, after becoming
the first British player to win the
tournament since Tony Jacklin in 1969.
18th July, 1985

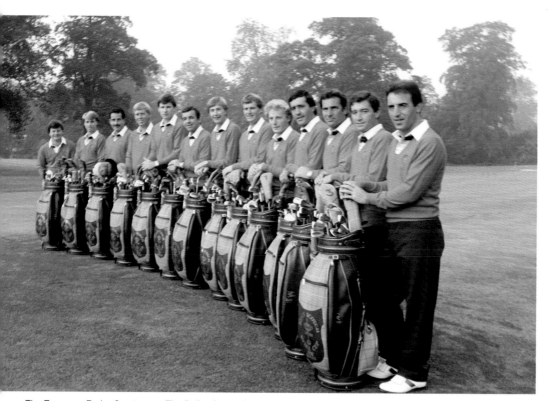

The European Ryder Cup team at The Belfry, Sutton Coldfield: (L–R) Ian Woosnam, Paul Way, Sam Torrance, Howard Clark, Nick Faldo, Tony Jacklin, Ken Brown, Sandy Lyle, Bernhard Langer, Seve Ballesteros, Jose-Maria Canizares, Manuel Pinero and Jose Rivero.

11th September, 1985

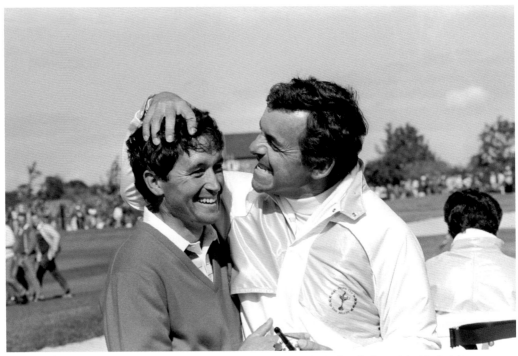

Europe captain Tony Jacklin (R) congratulates Manuel Pinero on his victory in the first singles match of the last day of the 26th Ryder Cup held at the Belfry. Europe would win the trophy for the first time since 1957 by a five-point margin.
15th September, 1985

Facing page: Triumphant captain Tony Jacklin admires the Ryder Cup after leading Europe to a historic win.
15th September, 1985

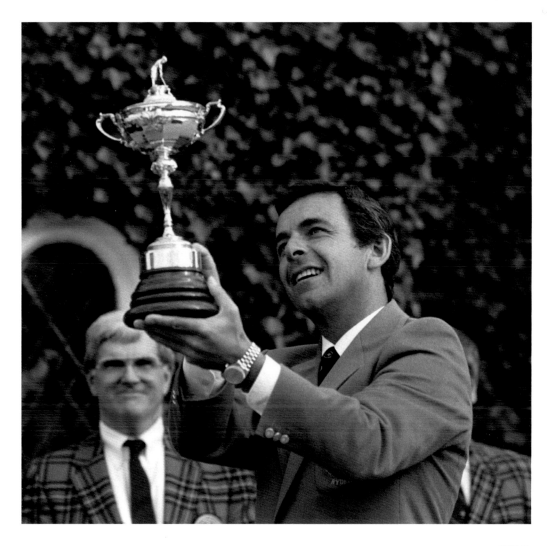

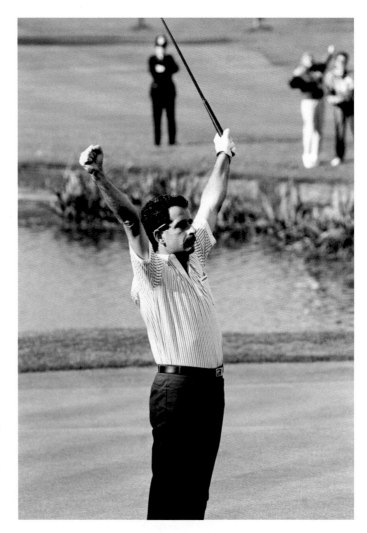

Scot Sam Torrance acknowledges the
cheering crowd after sinking a 20ft putt
for a birdie three to square the match
at the ninth in the afternoon four-ball
on the first day of the Ryder Cup at the
Belfry. Torrance and partner Howard
Clark would lose to the Americans Ray
Floyd and Larry Wadkins.
14th September, 1985

Greg Norman celebrates after
chipping the ball in from just off the
green during the Open Championship
at Turnberry. He beat Yorkshireman
Gordon J. Brand by five shots.
19th July, 1986

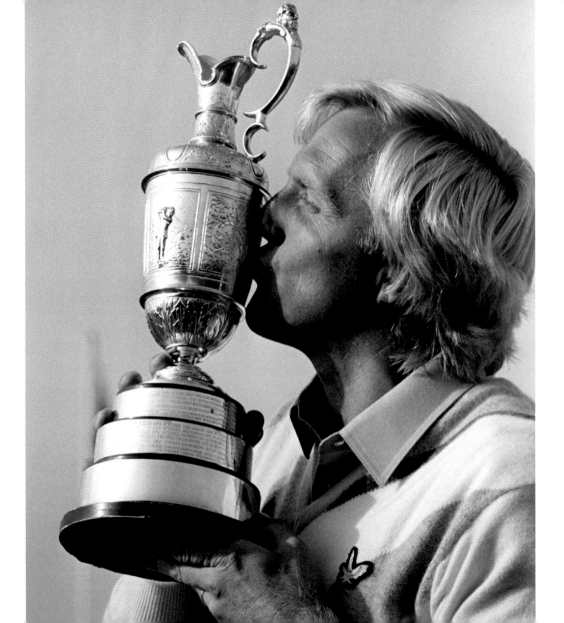

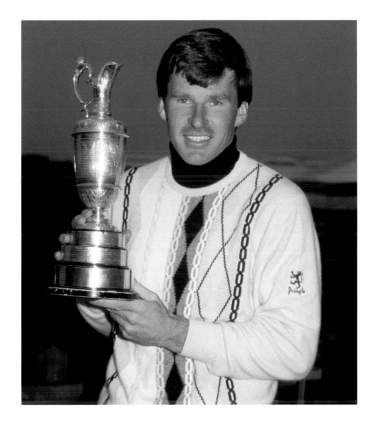

Nick Faldo celebrates winning his first Major, the 116th Open Championship at Muirfield. The Brit held his nerve to hit 18 pars in the final round and beat American Paul Azinger by one shot.
18th July, 1987

Facing page: Greg Norman after his victory at Turnberry. The 31-year-old Queenslander had reached the final pairings of all four Majors that year, but only won the British Open.
20th July, 1986

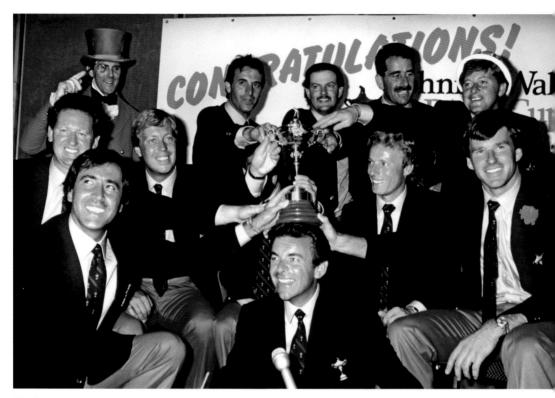

The European team at Heathrow Airport on their return to England after retaining the 27th Ryder Cup held at Dublin, in Ohio in the USA: (back row L–R) Jose Rivero, Gordon Brand Jr, Sam Torrance, Ian Woosnam; (middle row L–R) Eamonn Darcy, Howard Clark, Jose Maria Olazabal (hidden), Bernhard Langer, Nick Faldo; (front row L–R) Seve Ballesteros, and captain Tony Jacklin. The Europeans had beaten the American team on their home turf for the first time in 60 years of the competition.
28th September, 1987

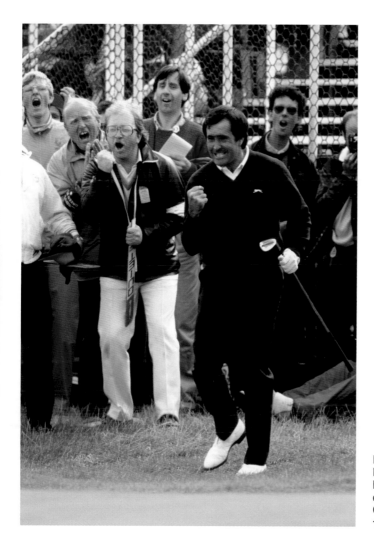

Ever-popular Spaniard Seve
Ballesteros and the crowd celebrate
his beautifully judged chip from the
edge of the 18th green in the British
Open at Royal Lytham & St Annes.
16th July, 1988

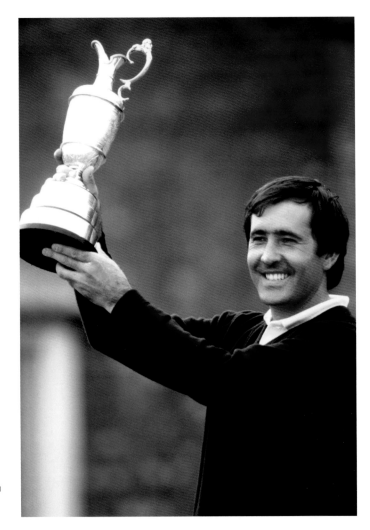

British Open Champion Seve
Ballesteros lifts the Claret Jug for the
third time, having beaten Zimbabwean
Nick Price by two shots.
16th July, 1988

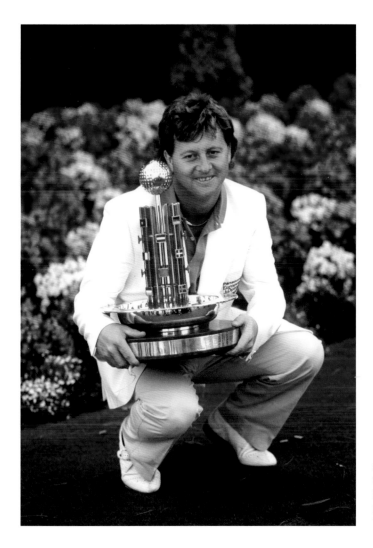

Wearing the winner's white jacket, Ian Woosnam relaxes with the Panasonic European Open trophy, which was played at Sunningdale in 1988.
11th September, 1988

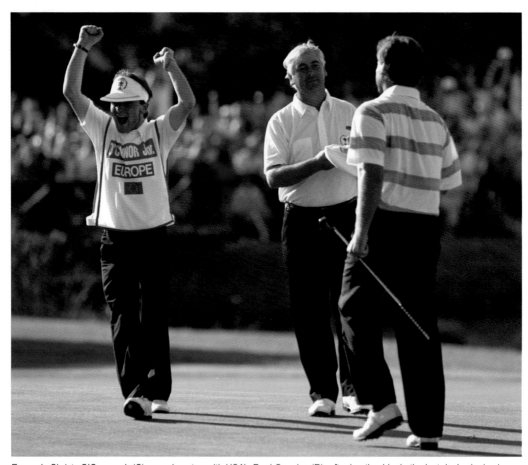

Europe's Christy O'Connor Jr (C) commiserates with USA's Fred Couples (R), after beating him in the last day's singles by one hole in the 28th Ryder Cup, while O'Connor's caddy (L) celebrates.
24th September, 1989

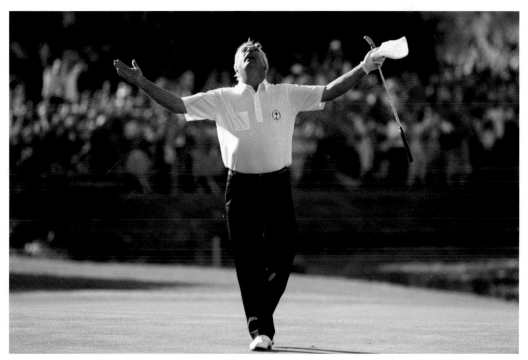

Christy O'Connor Jr looks to the heavens after his putt on the 18th hole at the Belfry won another point for the European Ryder Cup team. For only the second time in the competition's history, both teams finished level on 14 points each. As Europe had won outright on the last outing in 1987, Europe retained the Ryder Cup.

24th September, 1989

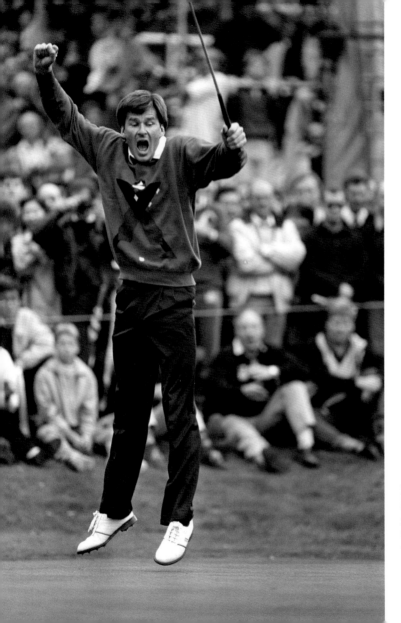

Joy for Nick Faldo after sinking the 20ft putt on the last green, which gave him victory over Ian Woosnam in the Suntory World Match Play Championship at Wentworth.
15th October, 1989

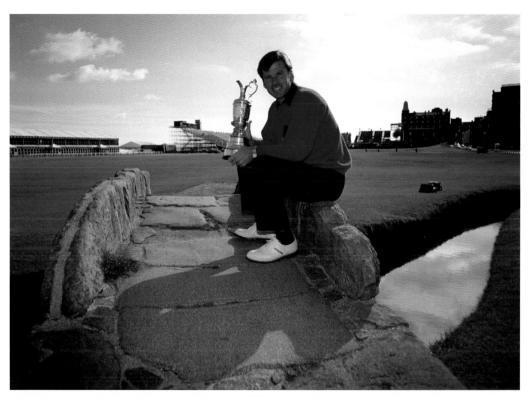

Nick Faldo sits on the Swilkan Bridge on the 18th fairway of St Andrews with the Open trophy. Faldo had dominated play on the Old Course, setting a scoring record of 18 under (only bettered by Tiger Woods), and winning by five strokes over runners-up Mark McNulty and Payne Stewart.

23rd July, 1990

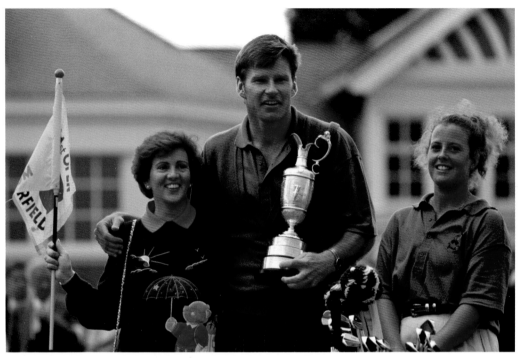

Nick Faldo won the Open Championship for the third time when it was played at Muirfield in 1992. Here he receives the plaudits of the crowd on the 18th green with his wife Gill (L) and caddy Fanny Sunesson after the presentation ceremony. Faldo just managed to hold off a challenge from American John Cook over the last few holes to finish one shot ahead.
19th July, 1992

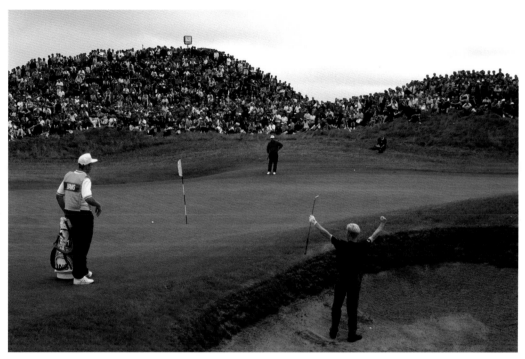

Gary Evans celebrates escaping the bunker by the sixth green, on his third attempt, during the second day of the British Open at Royal St George's. Australian Greg Norman would win the tournament by two strokes ahead of previous winner Nick Faldo with a final round of 64. Norman's playing partner that day, Bernhard Langer, called it the best round he'd ever seen.
16th July, 1993

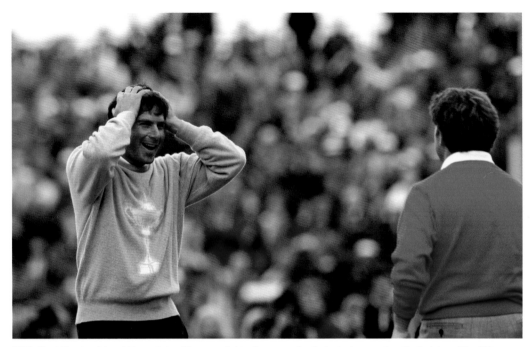

USA's Fred Couples (L) and Europe's Ian Woosnam finish all square after their singles round on the last day of the 30th Ryder Cup at the Belfry. The day would continue with Europe winning three of the first four singles matches, so everything was to hinge on the final afternoon's play.

26th September, 1993

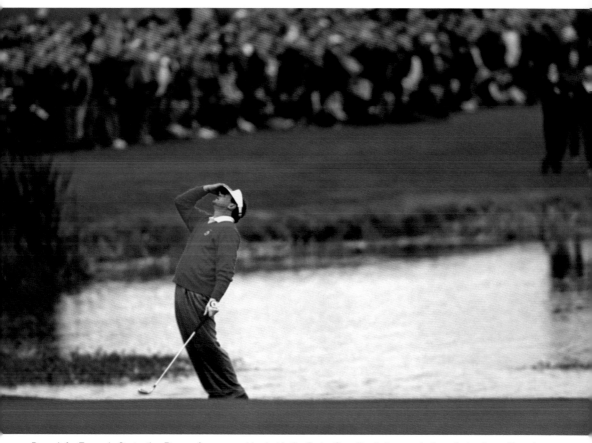

Despair for Europe's Costantino Rocca after a poor chip shot in the Ryder Cup. The Italian was in the unfortunate position of having to win his singles match against Davis Love III on the last day to secure the one point needed for Europe to win the Ryder Cup. With two holes to play, he had a lead of one shot, but he dropped shots on both the 17th and 18th to lose.
26th September, 1993

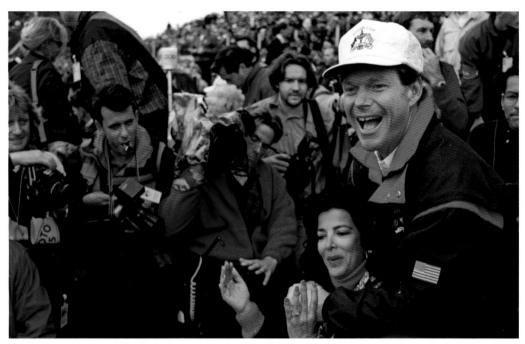

USA's captain Tom Watson and his wife watch with delight on the 18th green as his team seal victory in the 30th Ryder Cup at the Belfry. Europe went into the second afternoon with a three-point lead, but the Americans turned around their fortunes with three wins in the four-balls and then clinched the trophy on the last day with another six wins in the singles.

26th September, 1993

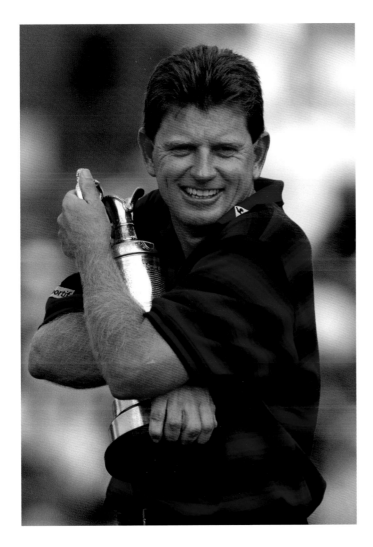

Nick Price hugs the trophy after
beating Swede Jesper Parnevik by
one shot in the Open Championship
held at Turnberry.
17th July, 1994

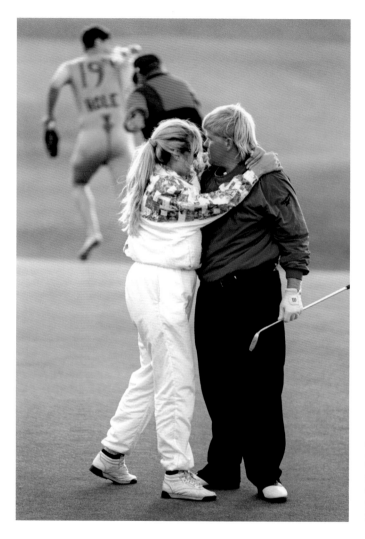

American John Daly's celebration with his wife, Paulette, on his way to winning the Open at St Andrews, is momentarily interrupted by a streaker, who races off in the background pursued by a course official.
23rd July, 1995

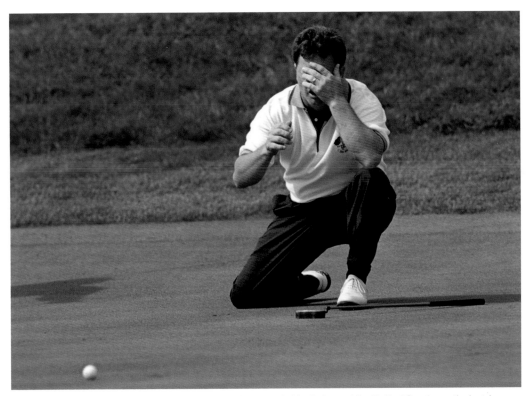

The rematch. Europe's Ian Woosnam bemoans just missing a putt in his singles match with Fred Couples on the last day of the 31st Ryder Cup, played at Oak Hill Country Club, Pittsford in New York. The two men would again halve their match, but this time the Europeans would go on to win the Cup by one point.

24th September, 1995

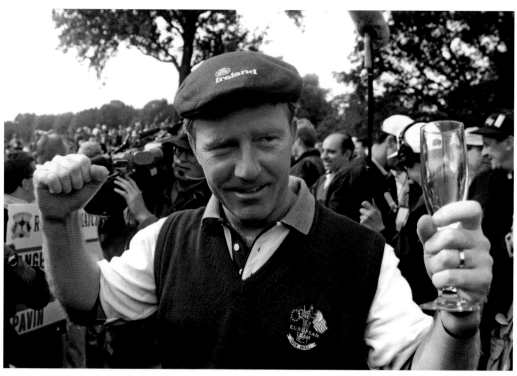

Irishman Philip Walton celebrates after his putt won his singles match against Jay Haas, delivering the final point needed to clinch the Ryder Cup for Europe. In another close finish, it was the Europeans who this time fought back on the last day, turning around a two-point deficit to win the competition by just one point.

24th September, 1995

Nick Faldo sinks to the floor after
receiving a rose from an admirer
on the fairway during the British
Open at St Andrews.
26th September, 1995

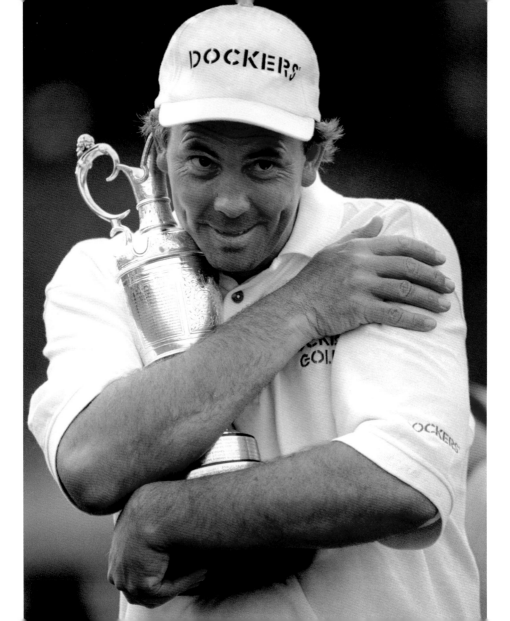

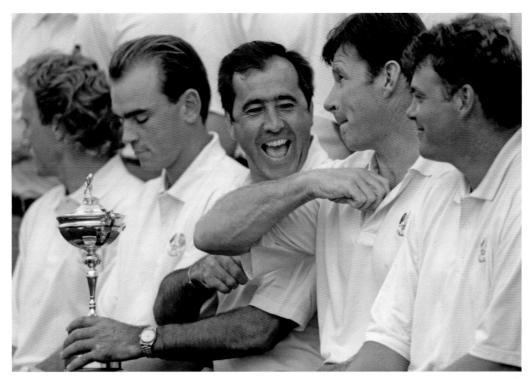

Europe's captain Seve Ballesteros (C) shares a joke with teammate Nick Faldo (second R) at the team picture session before the start of the 32nd Ryder Cup at Valderrama Golf Club, in Spain. Europe won the Cup by a single point on the last day.
24th September, 1997

Facing page: American Tom Lehman shows no sign of letting go of the Claret Jug, after winning the Open Championship at Royal Lytham & St Annes, his first Major.
21st July, 1996

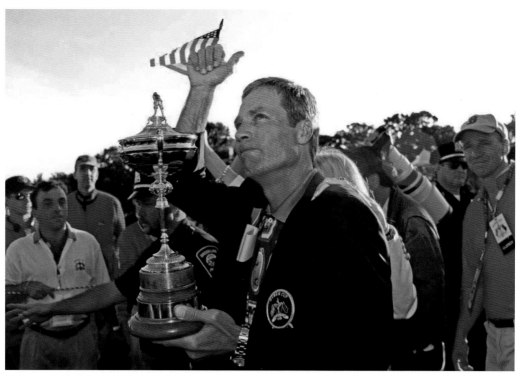

USA's captain Ben Crenshaw acknowledges the support of the home crowd as he celebrates winning the Ryder Cup. Europe had needed just four points from the last day's singles matches to claim the Cup, but heroic individual performances by the Americans, including Tom Lehman, Phil Mickelson, Davis Love III and Tiger Woods, were crucial to their success.
26th September, 1999

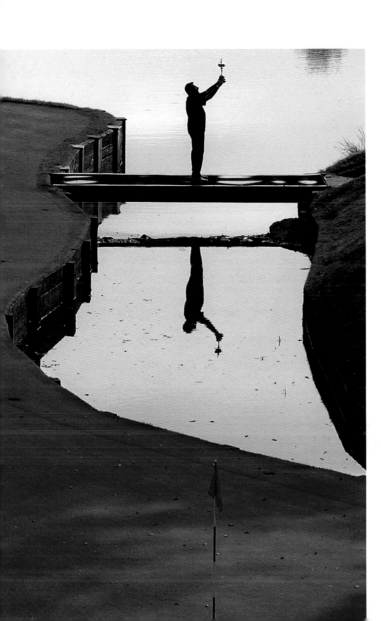

Sam Torrance holds the Ryder Cup on the bridge by the 10th green at the Belfry, marking Europe's victory in the 34th Ryder Cup. The event, scheduled for September 2001, was postponed after the terrorist attacks in the USA.
30th September, 2002

285

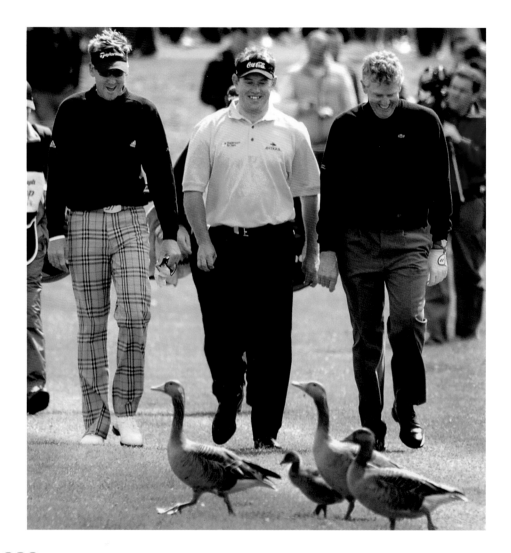

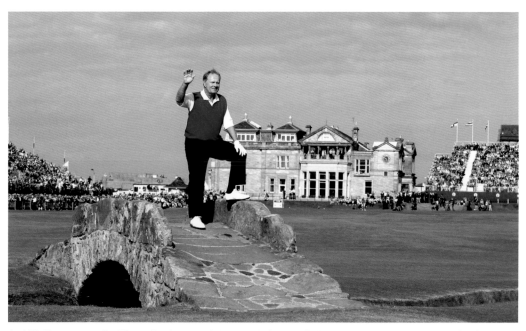

Jack Nicklaus waves a fond farewell to the appreciative crowds from the Swilkin bridge on the 18th hole of the Old Course at St Andrews. It was the American's last appearance as a competitor at the British Open, an event he had won three times.
15th July, 2005

Facing page: Local geese (and a gosling) cross the path of England's Ian Poulter (L) and Lee Westwood (C) and Scotland's Colin Montgomerie (R) on the seventh fairway during the *Daily Telegraph* Dunlop Masters at the Forest of Arden.
13th May, 2005

USA's Tiger Woods enjoys a ride on a golf cart during the rain-delayed practice for the 36th Ryder Cup at the K Club in County Kildare, in the Republic of Ireland.

20th September, 2006

European Ryder Cup player Sergio Garcia contemplates his putting during his final practice round at the K Club, County Kildare, ahead of the Ryder Cup opening ceremony later that day.
21st September, 2006

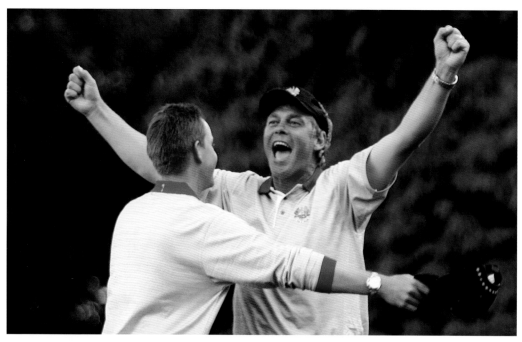

An emotional Darren Clarke (R) rejoices at the K Club after Swede Henrik
Stensen's (L) win over Vaughn Taylor sealed Europe's victory in the Ryder Cup.
It was the first time that Europe had won the contest three times in succession.
24th September, 2006

Facing page: Moments before Stenson's putt, Englishman Luke Donald had
ensured that Europe retained the Cup by defeating Chad Campbell at the 17th
hole. The Europeans equalled their 2004 record winning margin of nine points.
24th September, 2006

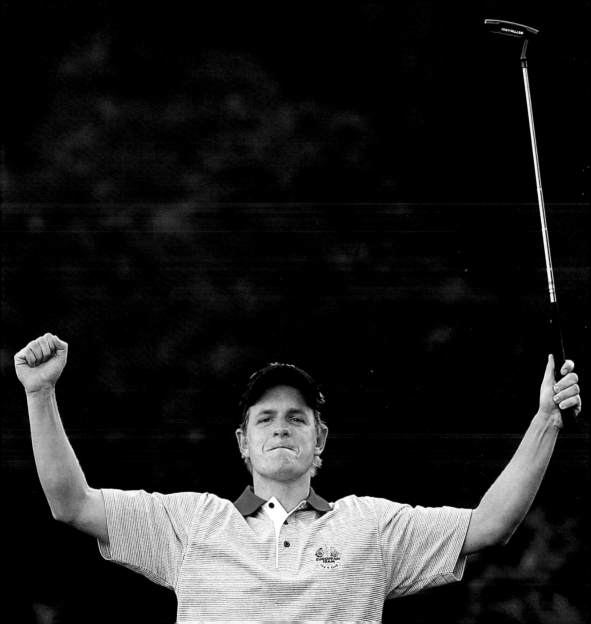

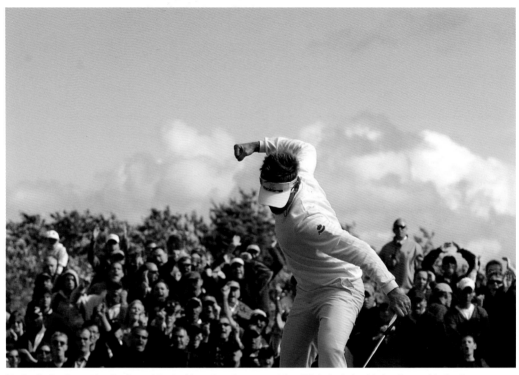

England's flamboyant Ian Poulter celebrates his putt on the green at the 16th hole during his fourth round in the Open Championship at Royal Birkdale. Poulter finished second, four strokes behind Irishman Padraig Harrington.
20th July, 2008

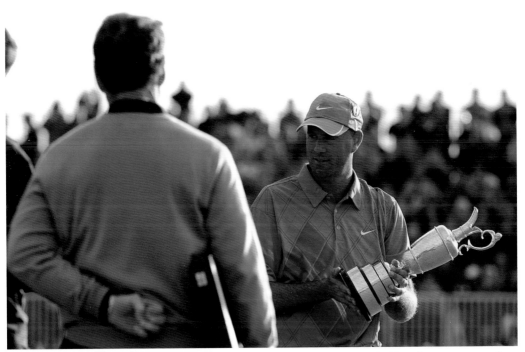

Tom Watson watches fellow American Stewart Cink receive the Open Trophy at Turnberry Golf Club. Twenty-two years after winning his last Major, and 32 years after his famous win over Jack Nicklaus on the same course, the 59-year-old Watson almost won for a sixth time, but he lost his lead on the last hole and then lost the title by six strokes in the four-hole play-off.
19th July, 2009

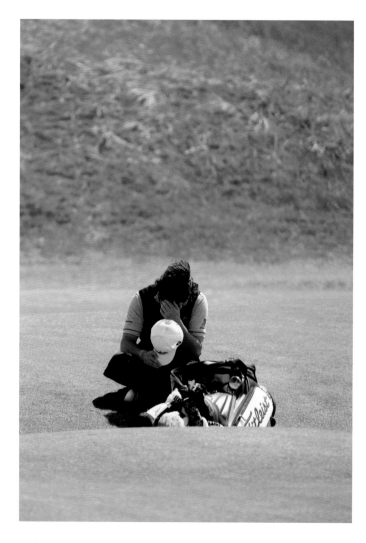

Northern Ireland's Rory McIlroy sits dejected on the fairway after play is suspended for high winds during the second round of the Open Championship 2010 at St Andrews. The young Northern Irishman had dominated play in the first round, but was blown off course in the second, eventually finishing tied for third.
16th July, 2010

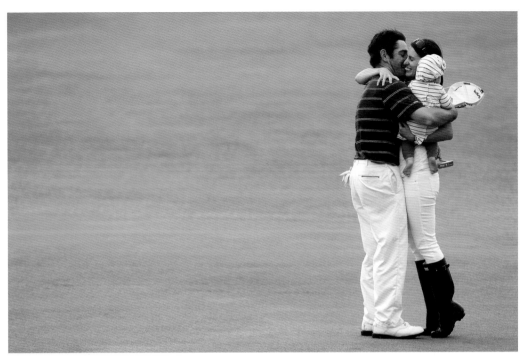

South Africa's Louis Oosthuizen celebrates with his wife Nel-Mare and daughter Jana after winning the British Open. In contrast to McIlroy, Oosthuizen avoided the high winds and took the lead after the seventh hole on his second round, never giving it up. Englishman Lee Westwood finished second.
18th July, 2010

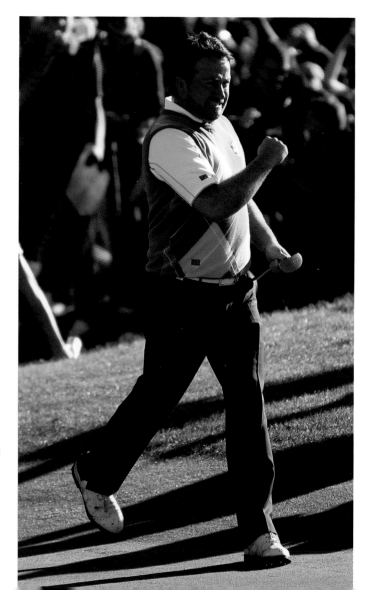

Northern Irishman Graeme McDowell
pumps his fist in jubilation after his putt
on the 16th hole in his singles match
against Hunter Mahan guaranteed
Europe's win in the 38th Ryder Cup at
Celtic Manor Resort in Wales.
4th October, 2010

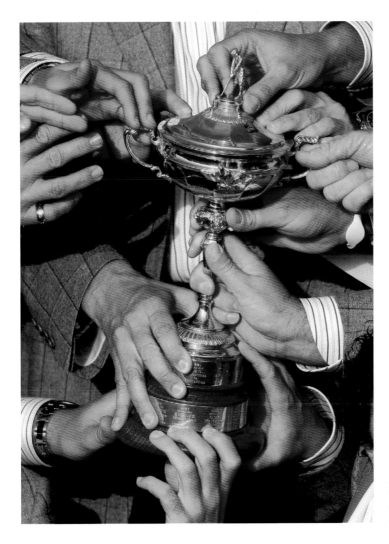

Hands on the prize. European captain Colin Montgomerie and team members take a firm hold of the Ryder Cup after their win.
4th October, 2010

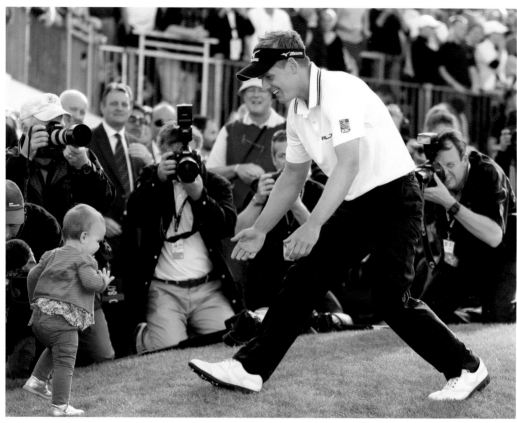

Luke Donald runs to hug his daughter Elle after winning the BMW PGA
Championship at Wentworth. Donald's victory in the play-off hole
over fellow Englishman Lee Westwood made him world number one.
29th May, 2011

Facing page: Swede Alexander Noren
throws his ball into the crowd after
winning the Saab Wales Open at
Celtic Manor Resort.
5th June, 2011

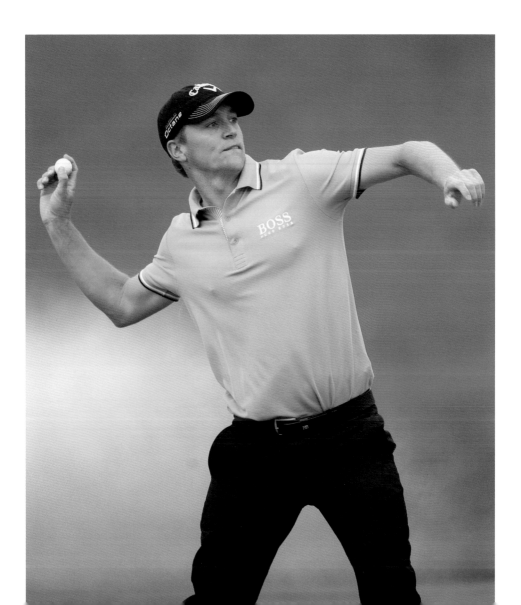

The Publishers gratefully acknowledge Press Association Images, from whose extensive archives the photographs in this book have been selected. Personal copies of the photographs in this book, and many others, may be ordered online at www.prints.paphotos.com

AMMONITE
PRESS

PRESS
ASSOCIATION
Images